FOG CITY

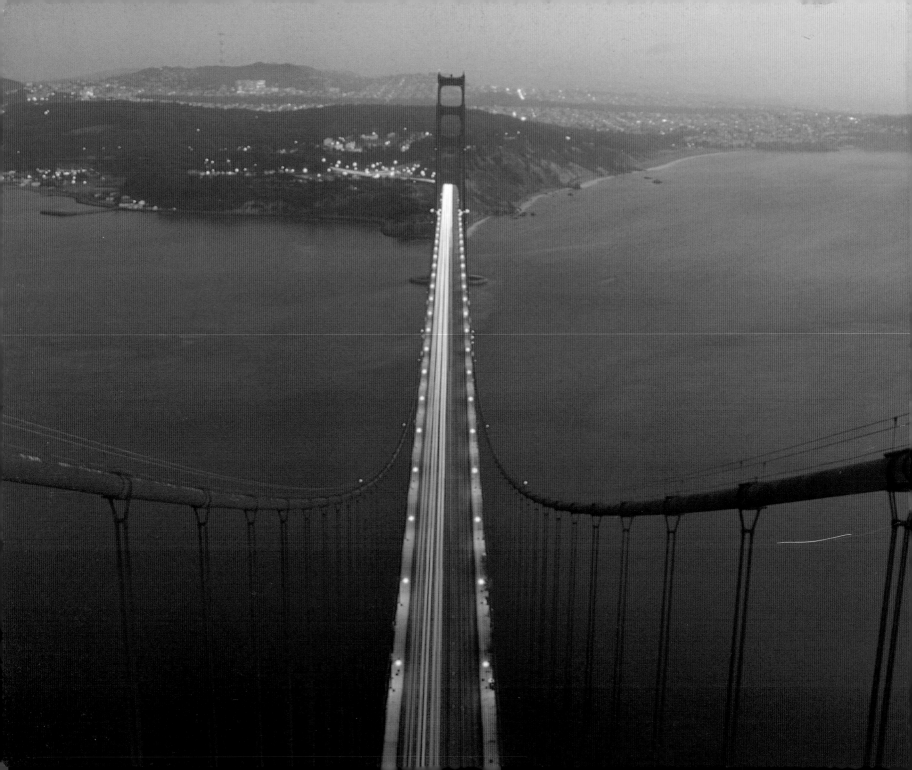

FOG CITY

Impressions of the San Francisco Bay Area in Fog

photographs by GALEN ROWELL

edited by JENNIFER BARRY

foreword by HAROLD GILLIAM

 SASQUATCH BOOKS
SEATTLE

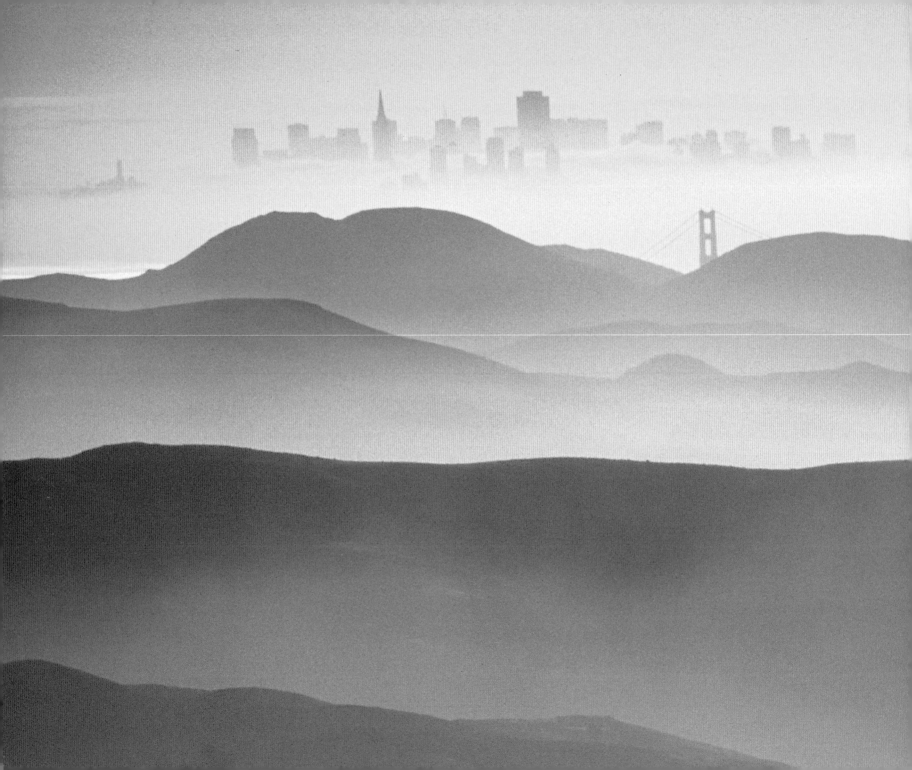

This city is a point upon a map of fog...

Like us, it doesn't quite exist.

AMBROSE BIERCE

FOREWORD

Mention fog to most people and you get a negative response.

Fog is dark, cold, clammy stuff that obscures your vision, causes automobile accidents, and infuriates not only drivers, but pilots of planes and ships and all who require clear and accurate visibility to do their work.

My own first experience with San Francisco Bay's fogs was close to terrifying. I was in the Army, had just returned from overseas at the end of World War II, and was spending my first night in a barracks at Crissy Field in the Presidio, hard by the Golden Gate.

In the middle of the night, I was awakened suddenly by what I thought was an explosion. The windows rattled, the bed vibrated, and I had an impulse to hit the ground as if it were a bombardment. But when the overwhelming sound continued for a few seconds, fell quiet, and was repeated a minute or so later, I realized that I was hearing not an explosion but a foghorn—one of the old, sonorous bass dia-phones trumpeting the arrival of the impenetrable mists that intermittently cover the Bay. I could hear other horns in the distance, a veritable chorus of tones and intervals.

After a few nights, I was able to sleep through the foghorn concert and rather missed it when it didn't come. During the next few weeks, walking into the city on my days off, I was able to observe the fantastic shapes of the San Francisco fog and its infinite variations.

On many late afternoons I watched a massive fog bank, backlighted by the lowering sun, move ponderously through the Golden Gate like an ice age glacier, a shape enveloping the bridge and advancing to Alcatraz and Angel Islands, where it rose to build vaporous domes in the sky. Then it continued across the Bay to Berkeley, where it formed a layer against the hills, spreading north and south.

From downtown San Francisco I could look toward the western end of Market or Mission Streets and watch as the white tide flowed over Twin Peaks in a slow-motion cascade. From Mount Tamalpais I could look down on the light flood moving from the ocean over the central Bay Area, leaving the hilltops as islands in a vaporous sea.

I was curious to learn more about this phenomena but discovered that almost nothing had been published about it. I wanted to write on the subject and looked for photographs to illustrate an article, but I found none.

Now at last, half a century later, the Bay Area fog has found its pictorial interpreter, its Edward Steichen, its Ansel Adams. Galen Rowell's images, each a work of art in itself, illuminate the physical and aesthetic splendor of our famous fog. He traveled the world with his cameras, capturing the essence of various landscapes, but returned here to his home ground to give photographic expression to one of this continent's most spectacular natural events.

Galen had a sharp eye, not only for the massive shapes of the flowing fogs but also for the nuances, the evanescent wisps of visible moisture that cling to ridges, trees, and canyon slopes, filtering the light with multiple variations. He captured this aerial show from scores of locations; at dawn, midday, and evening; at all seasons of the year. And accompanying his pictures are eloquent word portraits by poets and writers who, over the years, have responded to the region's land and weather in their own ways.

The geography of the Bay Area is both stunning and unique. Along most of the California coast, a mountain range rises out of the Pacific. The only sea-level break in that barrier is the Golden Gate, where the ocean has invaded the continent, creating San Francisco Bay and a water passage through the mountains to the vast basin of the Central Valley.

The prevailing northwest winds, blowing down the coast, laden with invisible moisture from their long transit across the Pacific, stir up cold currents of upwelled water from the sunless depths. Those currents act as a refrigerant, cooling the air above them until its vapor condenses into visible drops. The resulting fog bank hovers offshore along the California coast most of the summer and moves cyclically inland, pulled across San Francisco Bay and its shores by the heat of the Central Valley. The varied forms of the summer fogs are responses to the hill and valley and water of the Bay Area, as well as to larger forces in the atmosphere.

Rowell's acute observations are not limited to the summer fog; he portrays the winter fog as well, an entirely different phenomena, originating not over the ocean but inland. On winter nights after

substantial rains have soaked the earth, as the atmosphere grows colder, the moisture in the ground and in the air condenses into visible form.

The resulting "tule fog," so called because it often begins in the tule marshes of Sacramento-San Joaquin Delta, clings to the ground and moves slowly toward the ocean, sometimes blanketing the Bay and its shores but leaving the coast clear and sunny, a reversal of the summer coastal fog regime.

The pictures in this book not only document the fog, they also express the experiences of the photographer and, potentially, those of the viewer. Rowell's philosophy of "participatory photography" involved becoming "part of the events being photographed." He pointed out "the difference between a landscape viewed as scenery from a highway turnout and a portrait of the Earth as a living, breathing being that will never look the same twice."

As you inhale the salt breath of the ocean and watch the aerial waves moving inland like a whitewater surf, you are experiencing an extension of the rolling Pacific, the tangible presence and perennial mystery of the great ocean. Then you can identify with the circling winds, the flowing currents of air and sea, and the turning of the planet itself.

—Harold Gilliam, San Francisco

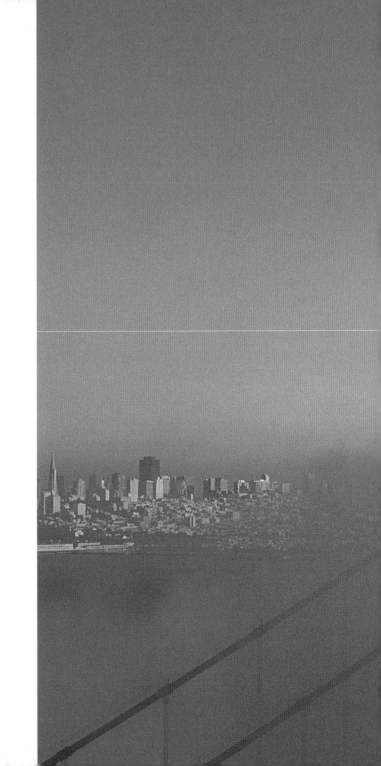

*There is nothing on earth exactly like the fog
of San Francisco Bay. None of the thousand evanescent forms of air
and water that move across the globe between the equator
and the poles is as fantastic in shape and motion yet as tangible and
intimate as the thick white vapor that rolls through the Golden Gate in
summertime like an air-borne flood and spreads to
the farthest reaches of the bay and its shores.*

HAROLD GILLIAM

Fog moving through the Golden Gate Bridge
toward San Francisco

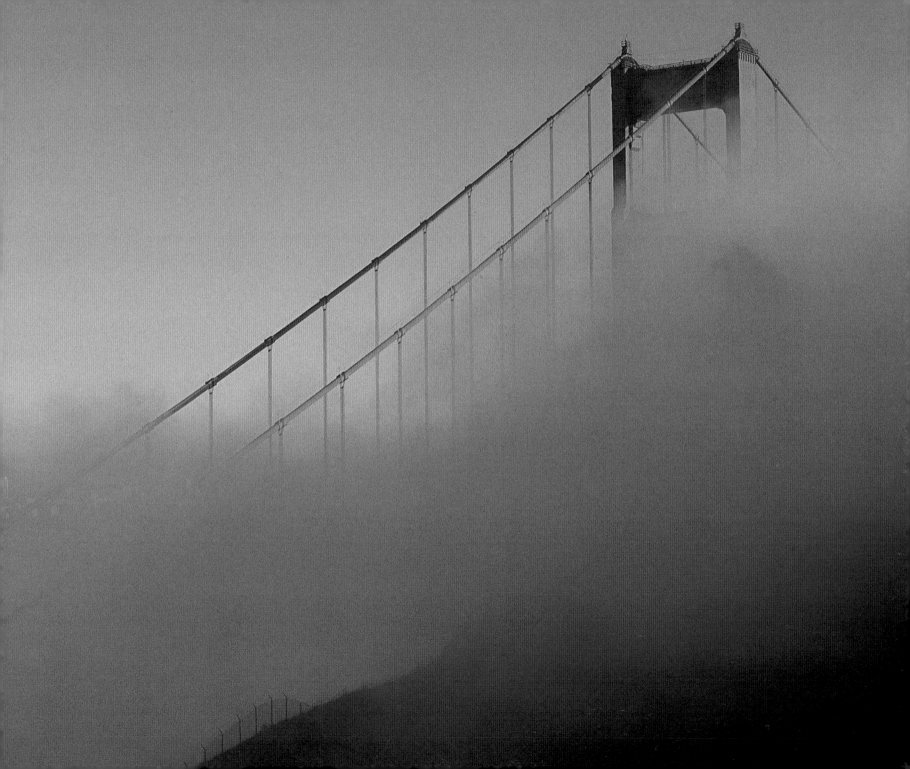

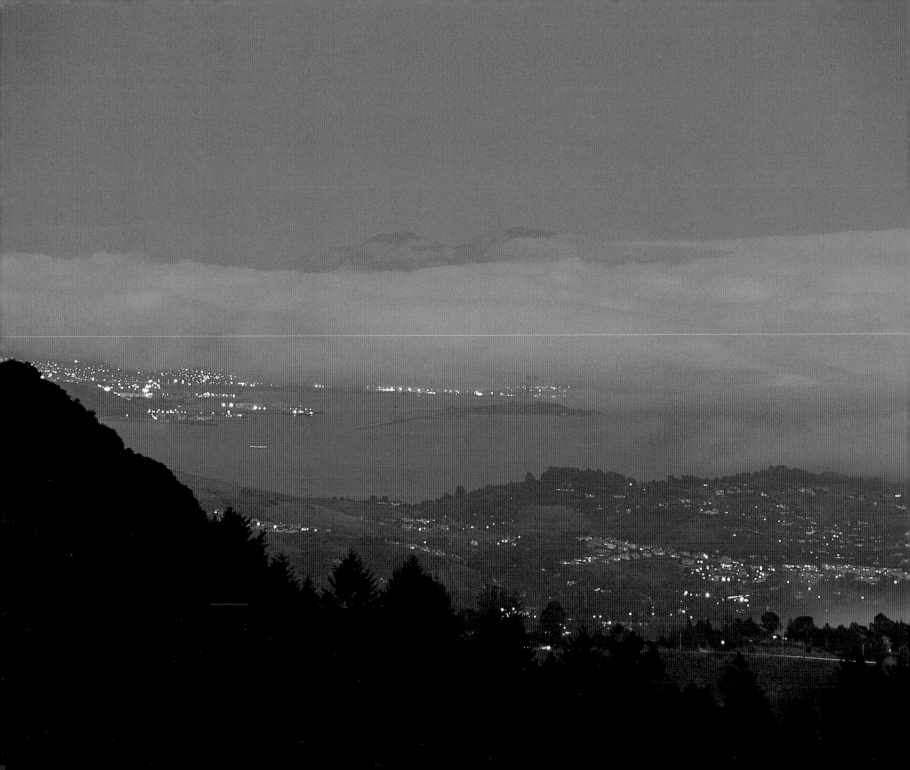

Fog is San Francisco's greatest asset. This sounds quixotic, but the statement is nevertheless true. For while fog is an active and permanent menace to navigation, a source of uncertainty and delay and worry to travellers, and carries a chill that goes to the very marrow of thinly-clad summer tourists, nevertheless it keeps the city cool in the summer and thus makes for health; also it keeps the city warm in winter, preventing frosts and moderating the fall in temperature.

ALEXANDER MCADIE

Dawn from Mount Tamalpais over San Francisco
Bay *(left),* and aerial view of Chabot Regional Park
and San Francisco Bay *(right)*

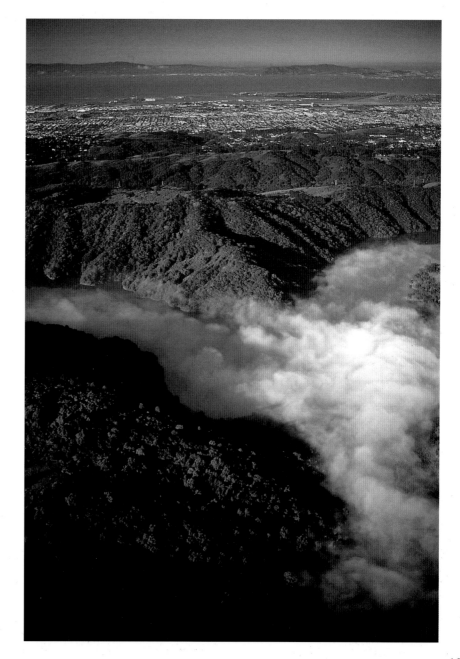

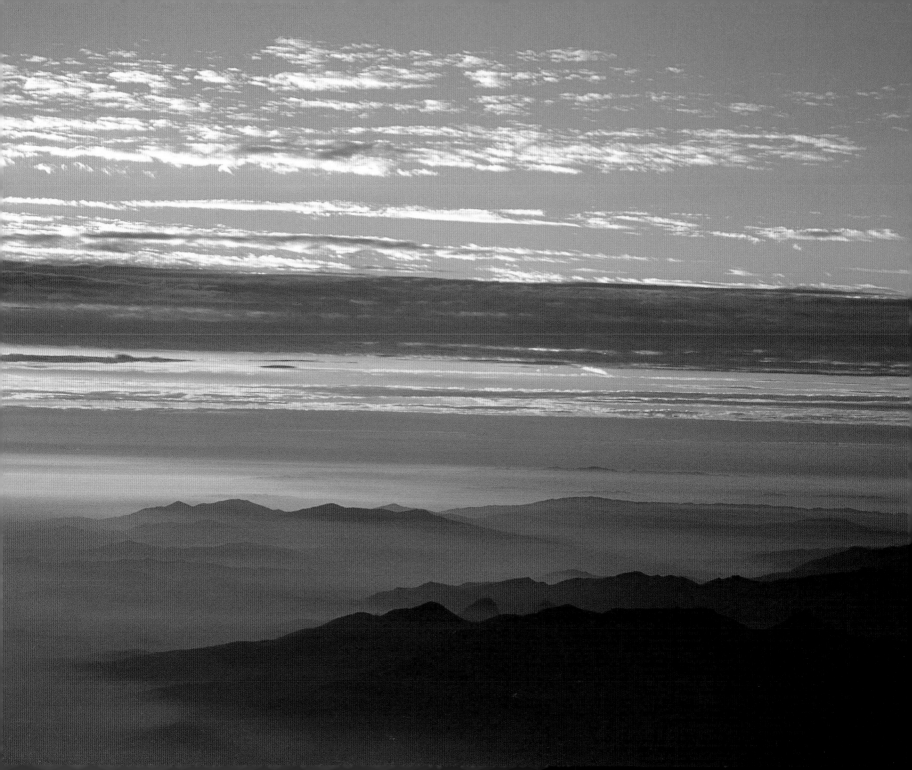

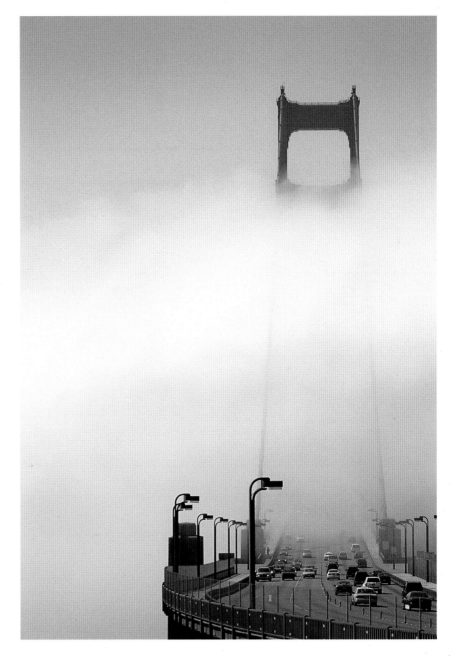

At daybreak, the fog below is a stormy, swirling plain. The sun rises, the fog breaks, and the waters of the bay appear, the outlines of the islands and headlands, sheaves of skyscrapers. Dew drips from the pines, hummingbirds can be heard whirring in the bushes by the window. The traffic on the roads and bridges increases, a glimmering multitude of microscopic points. Then I, too, join everyone rushing in pursuit of their goals and I become part of the great operation.

CZESLAW MILOSZ

Diablo Range from the South Bay
at dawn *(left),* and the Golden Gate
Bridge *(right)* in fog

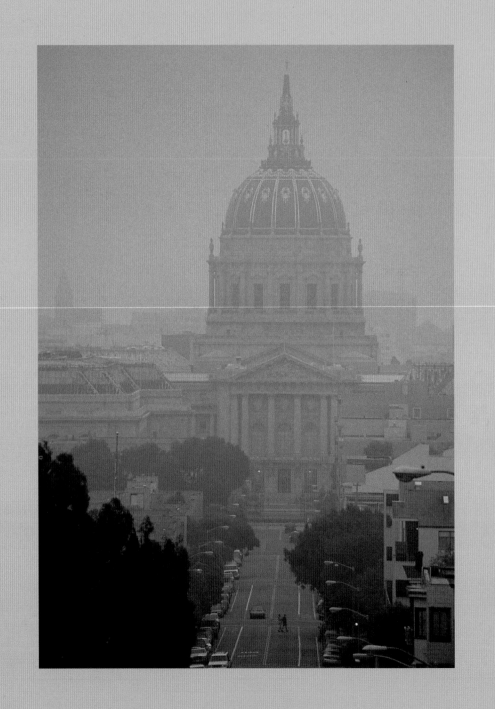

Drop down, O fleecy Fog, and hide

Her skeptic sneer, and all her pride!

Wrap her, O Fog, in gown and hood

Of her Franciscan Brotherhood.

BRET HARTE

San Francisco City Hall

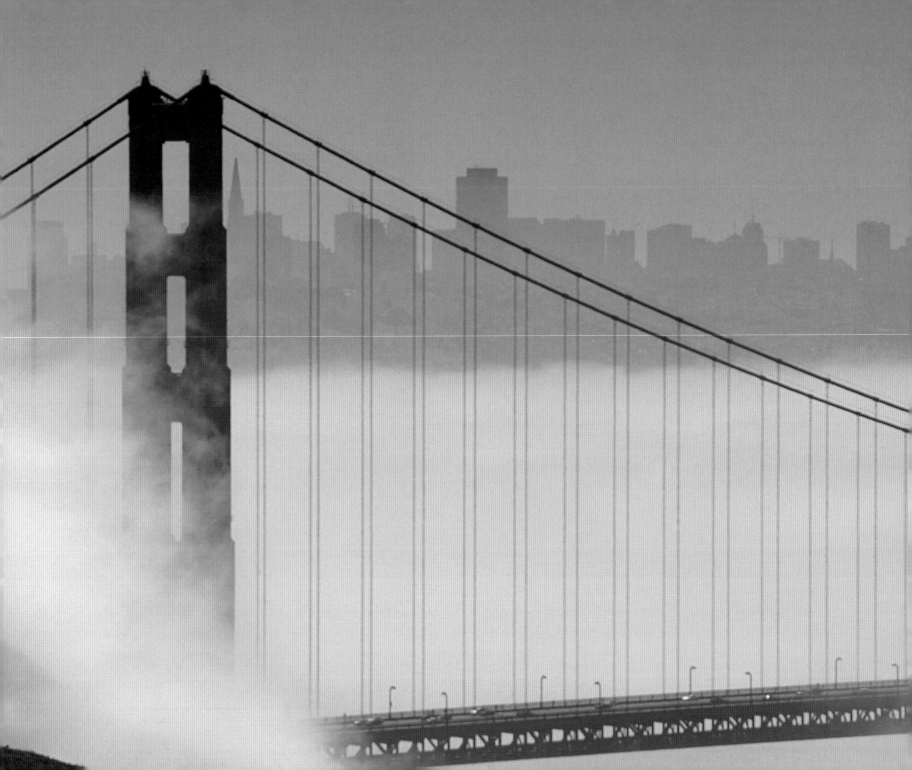

*Newly formed whitish fog filtering through the harp strings of
the Golden Gate Bridge and then puffing out its chest as though
pleased with its dramatic entrance; but the only applause is the
quiet lapping of the waves as they disappear under the silent
mass . . . The deserted midtown streets after midnight, punctuated
by the sound of a window closing suddenly, the sharp click of
an apartment-house door, a radio playing softly down the hall,
the rattle of cabs taking girls from their own hotel to somebody
else's . . . The Sunday golfers hard at play on the broad green acres
in Lincoln Park and the Presidio and Harding Park and Lakeside,
while the kids of North Beach tumble down the hills on home-
made gadgets and the kids of Chinatown play handball against
a saloon wall and the kids of the Mission shinny up telephone
poles and get calluses on their hearts.*

*The cable-car conductors running to the rear platform to
signal a sudden turn, the cabbies stopping suddenly with no signal
whatever, the tiny old houses with the million-dollar views, the
financial district skyscrapers whose denizens are too busy to look
out the windows, the restaurants where you can "eat around
the world," and the old people who have come around the
world to find something to eat . . . All this, and so much more,
is San Francisco.*

HERB CAEN

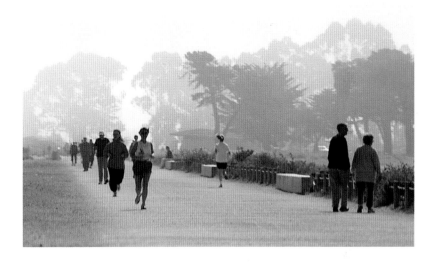

Golden Gate Bridge, San Francisco *(left)*,
and Golden Gate Promenade, Presidio of
San Francisco *(right)*

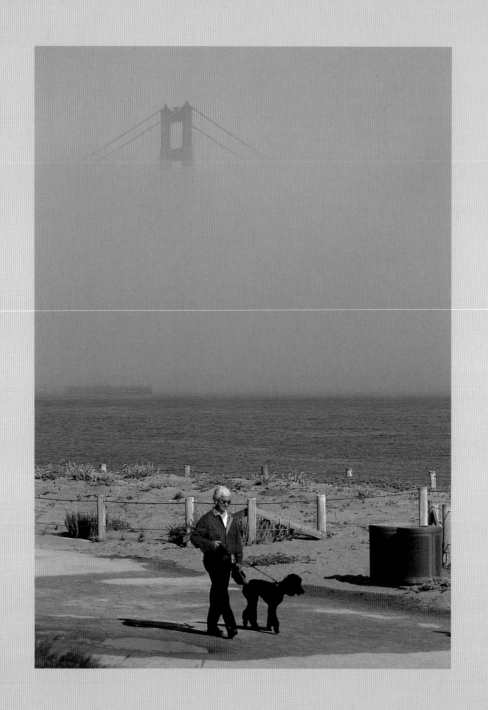

San Francisco is notorious for having

its foggy streets and its sunny streets.

The sea mists swirl in through

natural draws and along channels formed

by the valleys of this hilly city.

In the warmer and more protected

sections, housewives can garden

in cotton dresses. In others, shoppers

must button into wool coats against

the chill and clammy winds.

ELNA BAKKER

Golden Gate Promenade near
Marina Green, San Francisco

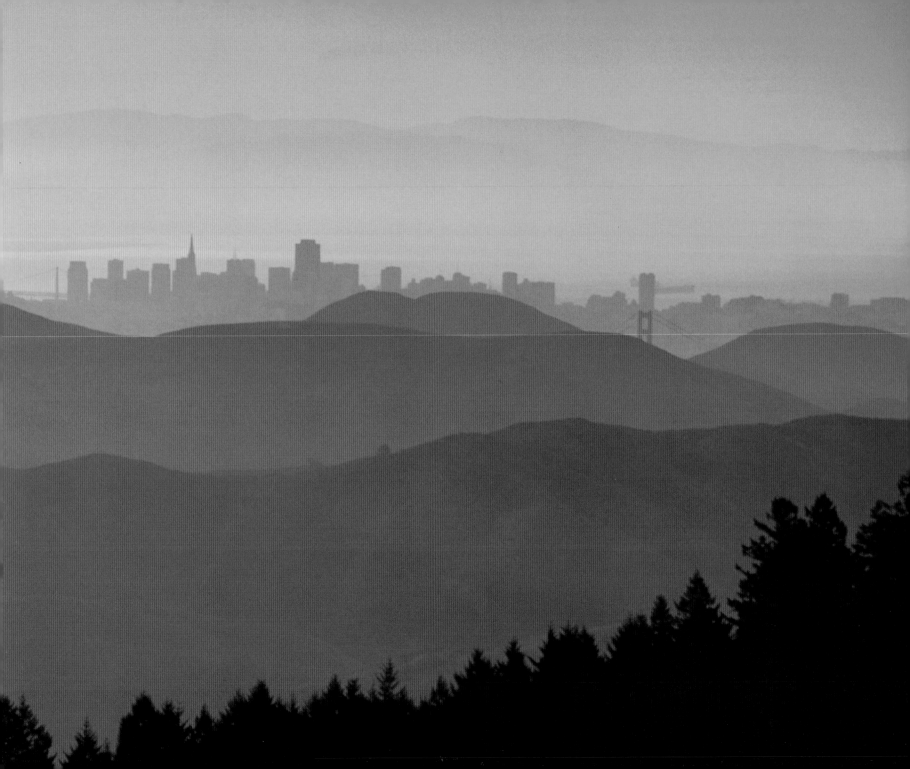

Dust always blowing about the town

Except when sea–fog laid it down.

And I was one of the children told

Some of the blowing dust was gold.

ROBERT FROST

San Francisco at dawn from Mount Tamalpais

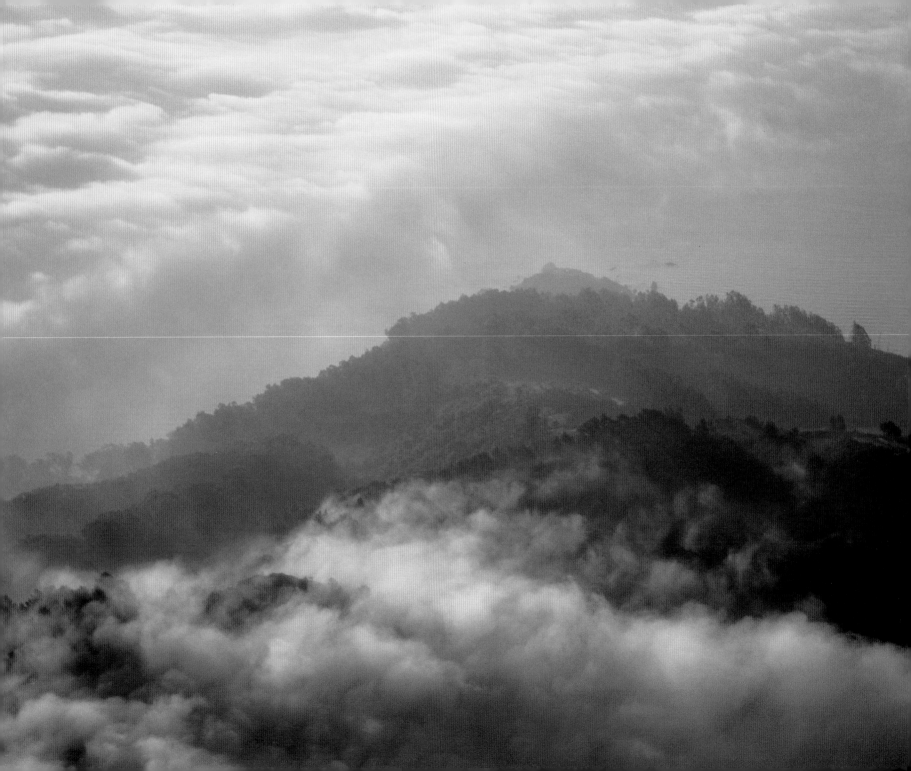

When the fog in San Francisco Bay
moves back out towards the sea
it looses its grip on the Berkeley hills,
lowers down over the water, moves
out through the Golden Gate Bridge
leaving a halo of fog around the
island standing in its path.

SHAWN H. WONG

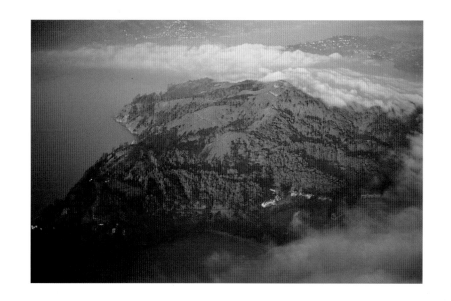

Fog over Angel Island

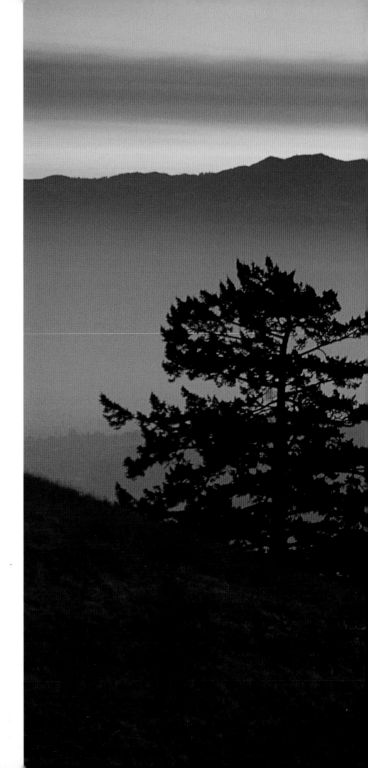

In California in the early spring
there are pale yellow mornings
when the mist burns slowly into day.
The air stings
like autumn, clarifies
like pain.

ROBERT HASS

Sunrise at Windy Hill Preserve above Palo Alto

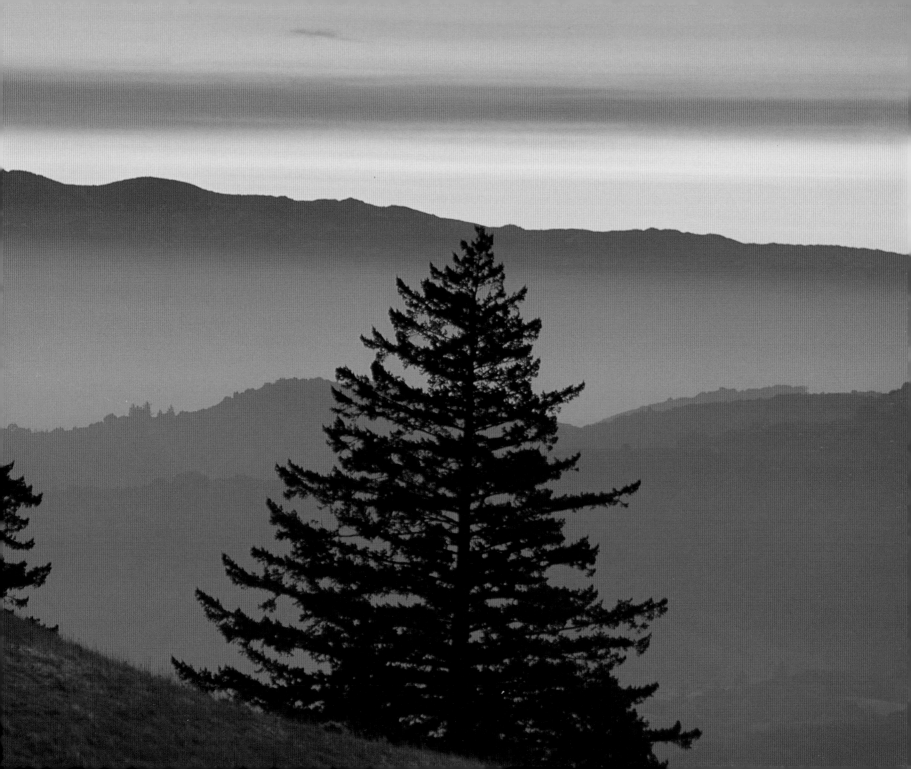

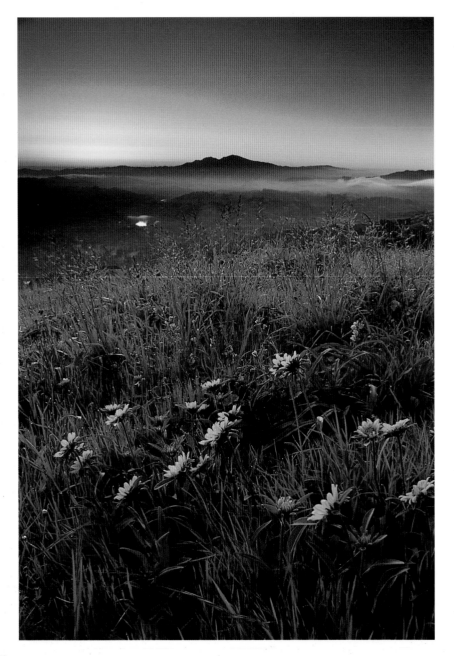

I come to you with a flower whose face

Is the zenith of beauty, the acme of grace;

There are dreams in its eyes, and the song on its lips

Is the lullaby song of the shadow that slips

O'er the tall purple mountain that watches like Fate

The silver sails threading the fair Golden Gate.

CLARENCE URMY

Mule Ears and Mount Diablo *(left)*, and tule fog over
the East Bay interior surrounding Mount Diablo *(right)*

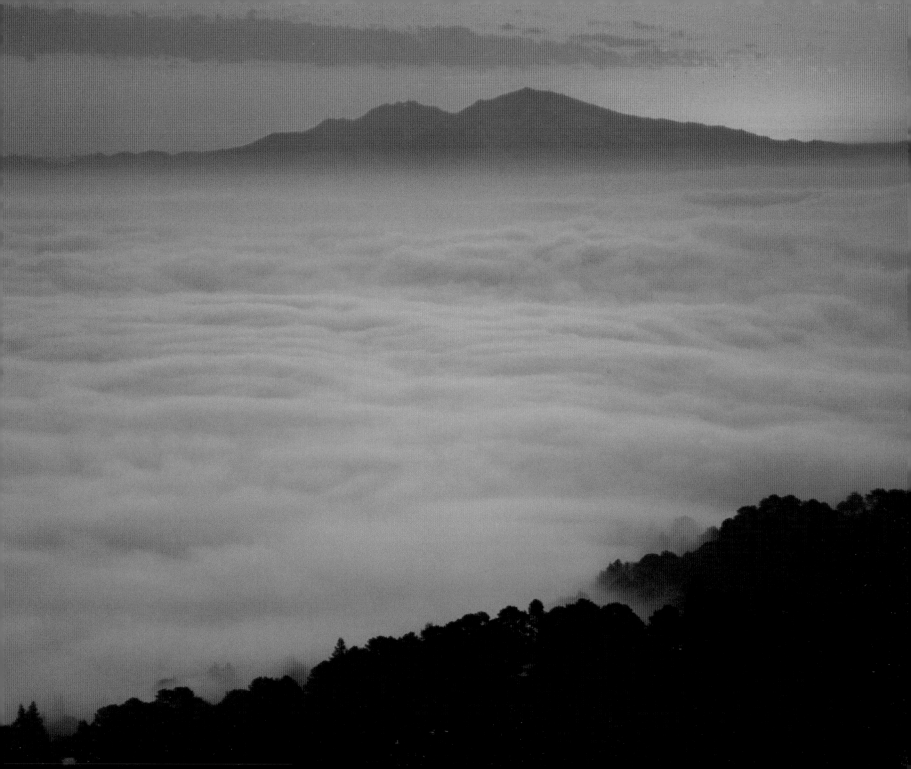

Only the cedars do not tire of fog;

They drip patiently through days,

Gathering mist and letting it fall.

I have lain in bed and heard the fog-drip

Tap all night upon the ground,

Given by the silver boughs

In renitent release.

WILLIAM EVERSON

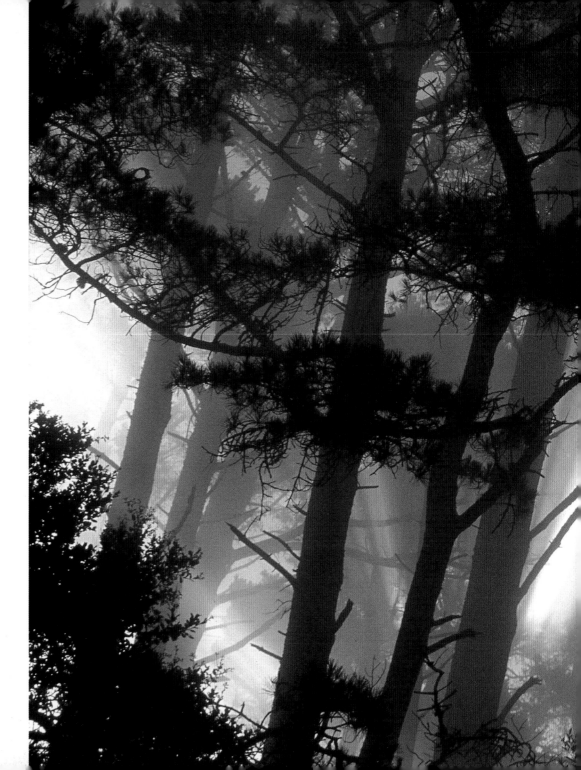

God beams in Monterey pine forest,
Tilden Regional Park, Berkeley

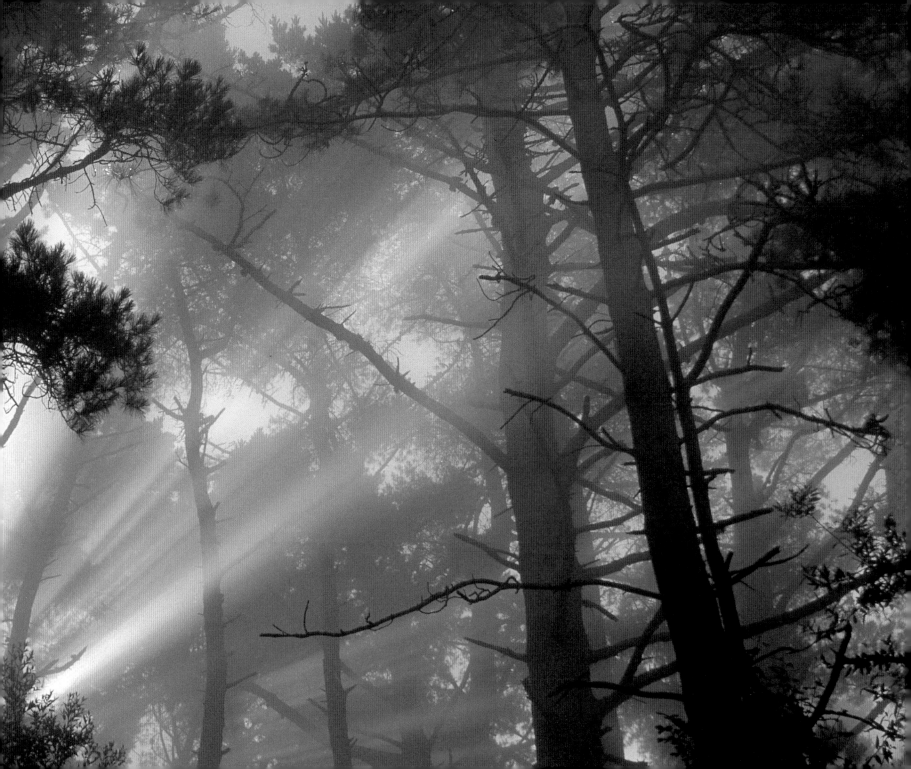

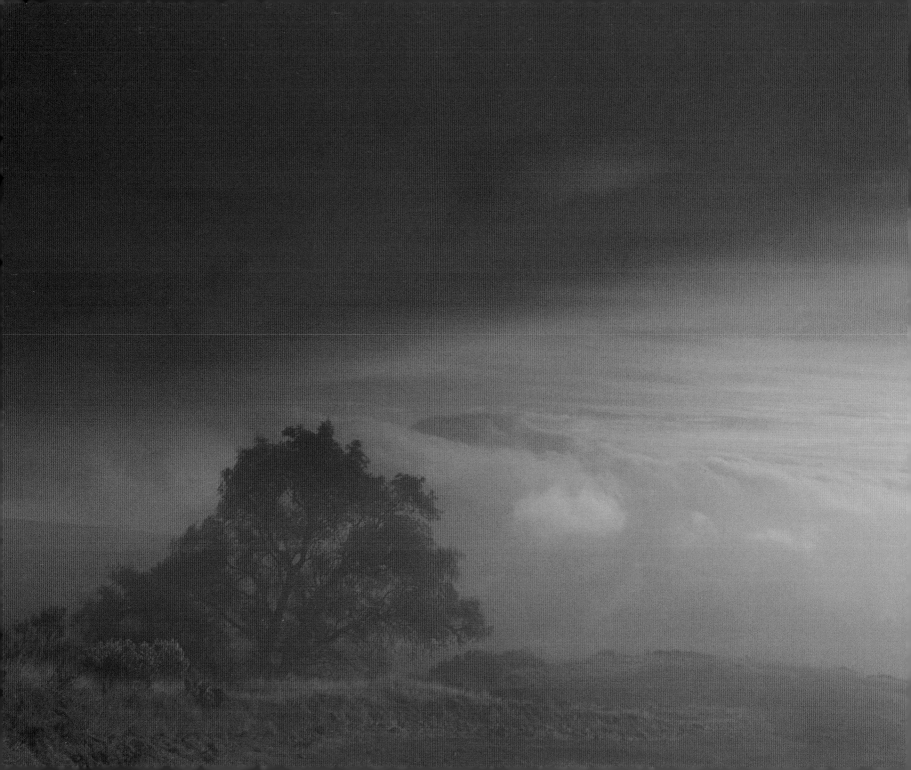

As I ascended the mountain-side, I came once more to overlook the upper surface of the fog; but it wore a different appearance from what I had beheld at daybreak. . . . and its surface shone and undulated like a great nor'land moor country, sheeted with untrodden morning snow. And the new level must have been a thousand or fifteen hundred feet higher than the old, so that only five or six points of all the broken country below me, still stood out.

ROBERT LOUIS STEVENSON

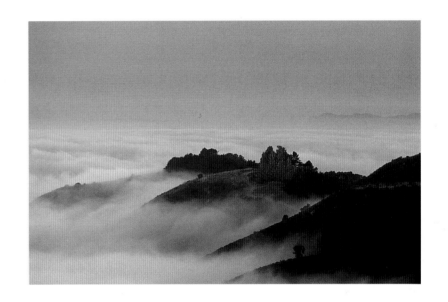

Misty fall morning on Vollmer Peak looking toward
Briones Reservoir *(left),* and ridge of Claremont
Canyon rising over the fog-draped Bay *(right)*

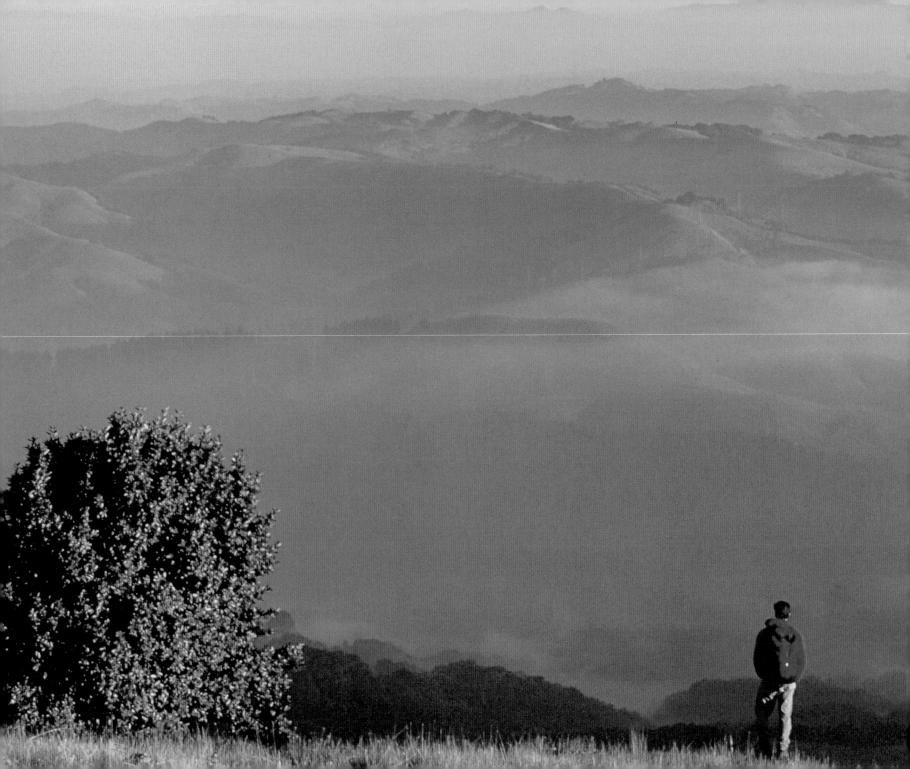

We were set just out of the wind, and but just

above the fog; we could listen to the voice of

the one as to music on the stage; we could

plunge our eyes down into the other, as into

some flowing stream from over the parapet of

a bridge; thus we looked on upon a strange,

impetuous, silent, shifting exhibition of

the powers of nature, and saw the familiar

landscape changing from moment to moment

like figures in a dream.

ROBERT LOUIS STEVENSON

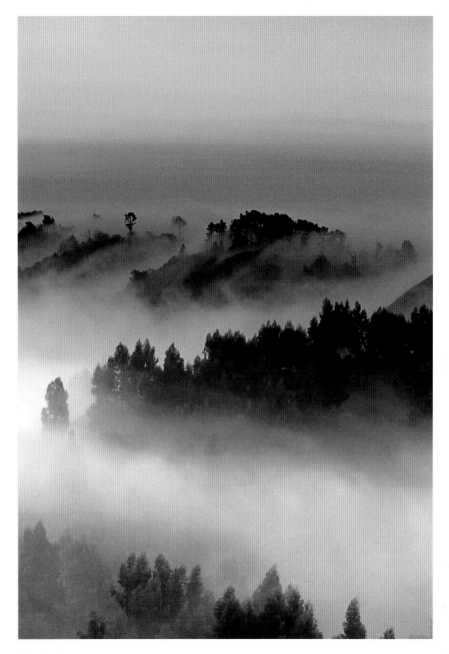

Looking east from the Berkeley Hills on
a winter morning *(left)*, and crest of the
Berkeley Hills blanketed by fog *(right)*

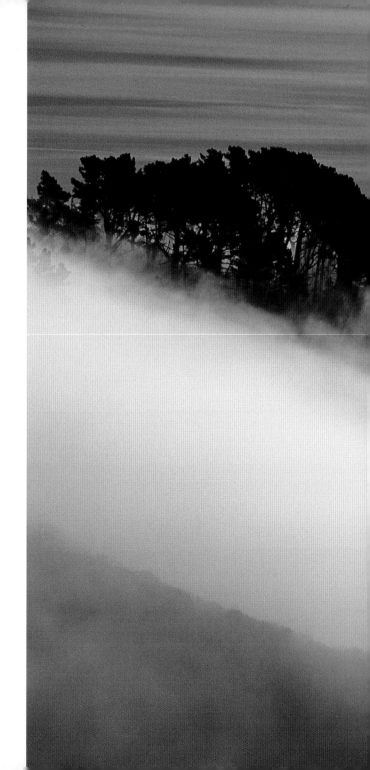

. . . Over the near ridges on the other side, the deluge was immense. A spray of thin vapour was thrown high above it, rising and falling, and blown into fantastic shapes. The speed of its course was like a mountain torrent. Here and there a few treetops were discovered and then whelmed again; and for one second, the bough of a dead pine beckoned out of the spray like the arm of a drowning man.

ROBERT LOUIS STEVENSON

Fog pouring over the Berkeley Hills

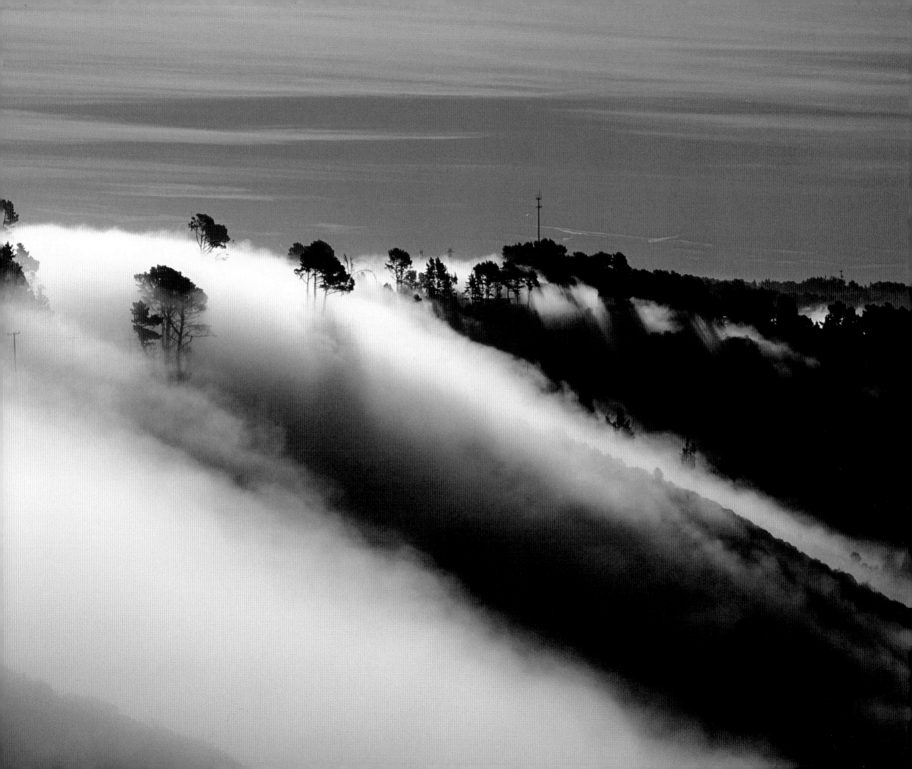

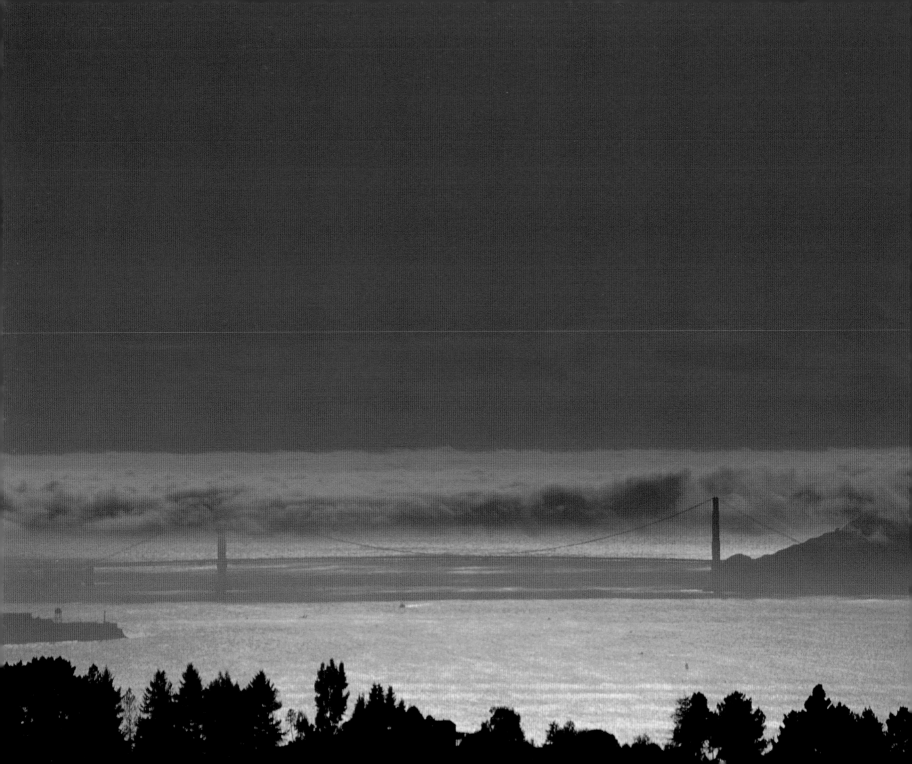

Often as I gazed out my windows, I wanted to peel back that human skin to see what it had been once. I tried to imagine the thoughts of those first European sailors who chanced to come through the fog bank always masking the estuary, through the Golden Gate into the sun-swept, glistening bay. Were they not stunned? Were they not seduced by the land, realizing itself forever eastward? Did it not come to mind that this was a new Eden, a new chance to start the human story all over again?

NATHAN IRVIN HUGGINS

Summer fog advancing on the Golden Gate

And are we not today somewhat like the crew of the Golden Hinde *in that we do not see beyond the veil of the immediate present and dream not of the possibilities of the future? There is more to a bank of fog than the accidental grouping of little globules of condensed water vapor. There is a reason for the massing and there are processes at work which if understood and mastered would lead to marvellous achievement. It is as difficult for us to conceive of future methods of communication and transportation as it was for the sailors of Drake's age to imagine a steam driven ship.*

ALEXANDER MCADIE

Sailing toward San Francisco

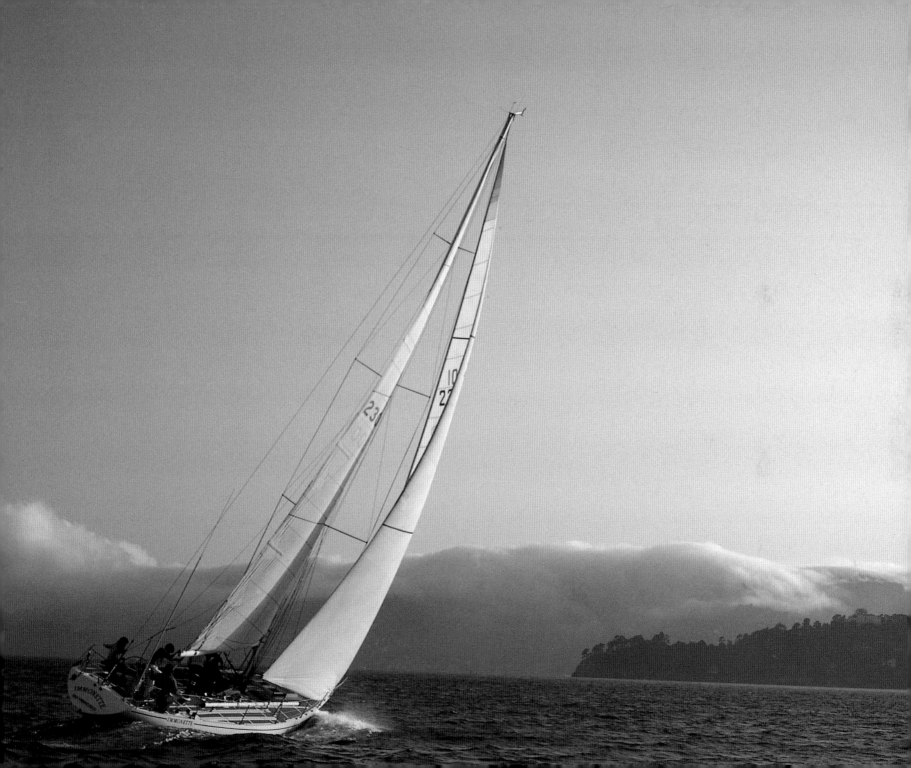

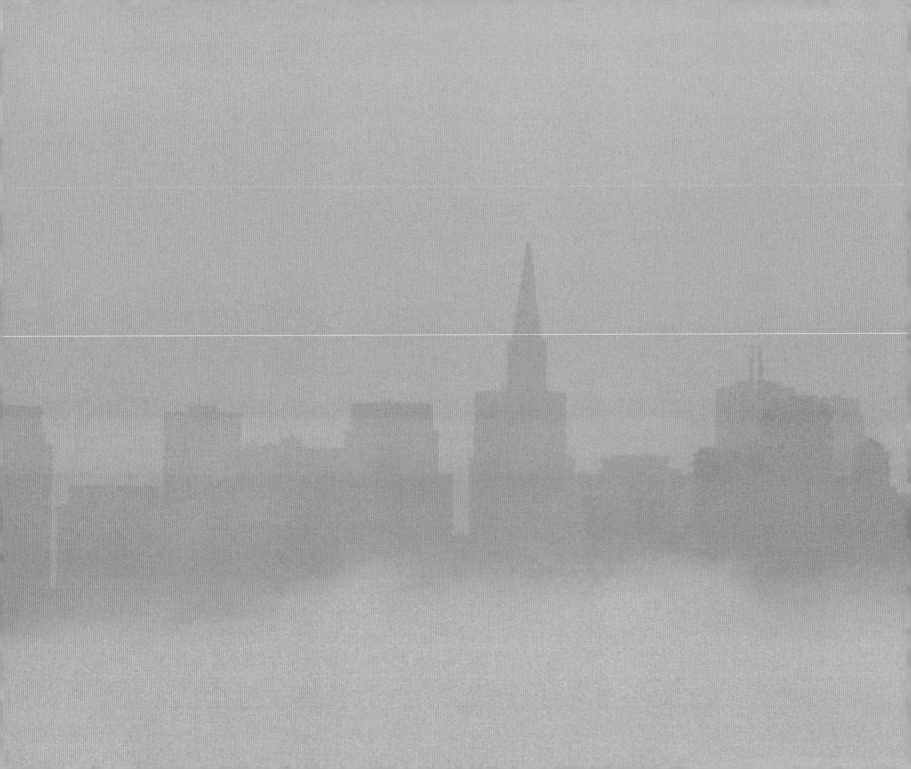

Tho the dark be cold and blind,
Yet her sea-fog's touch is kind,
And her mightier caress
Is joy and the pain thereof;
And great is thy tenderness,
O cool, grey city of love!

GEORGE STERLING

San Francisco in fog

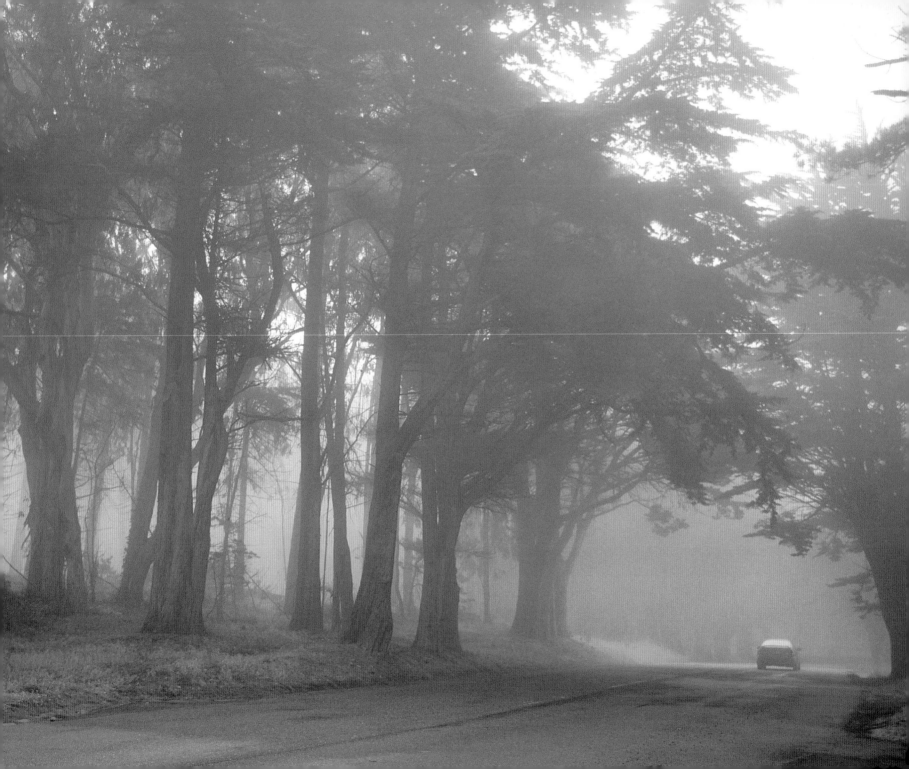

Another gray morning

in this month of valley fog.

Everything seems old, little threads and roots

sucking a cold sea.

When I look into it, the mirror

cups my face in its silver hands.

PETER EVERWINE

Grounds of the Presidio of San Francisco

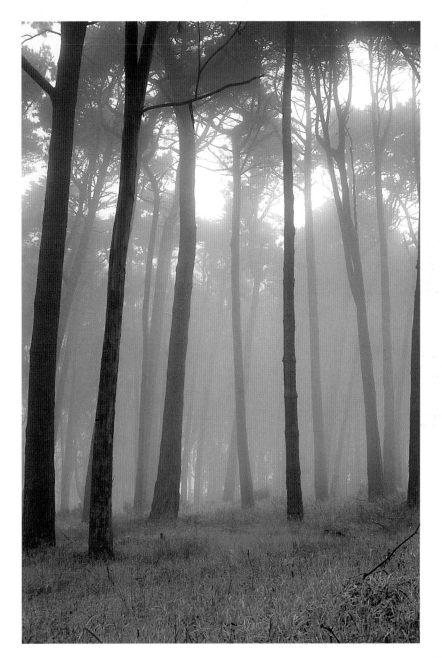

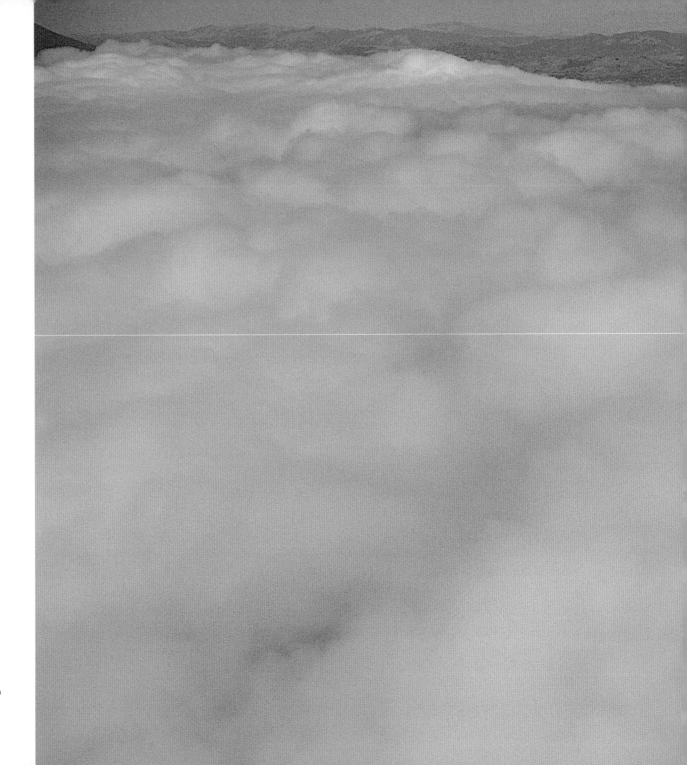

Sutro Tower, San Francisco

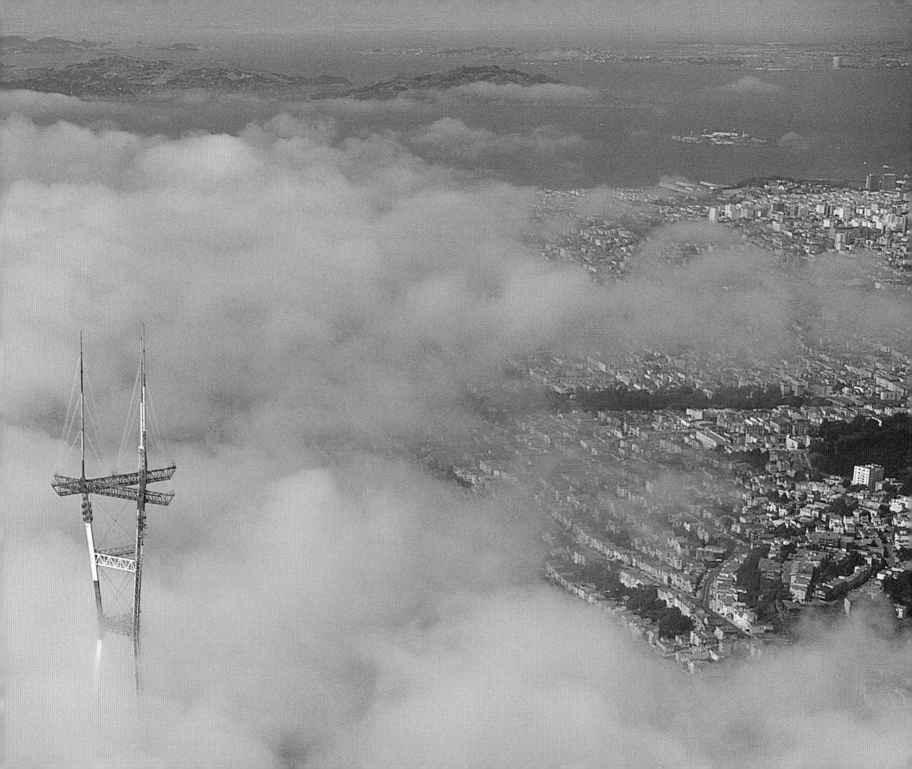

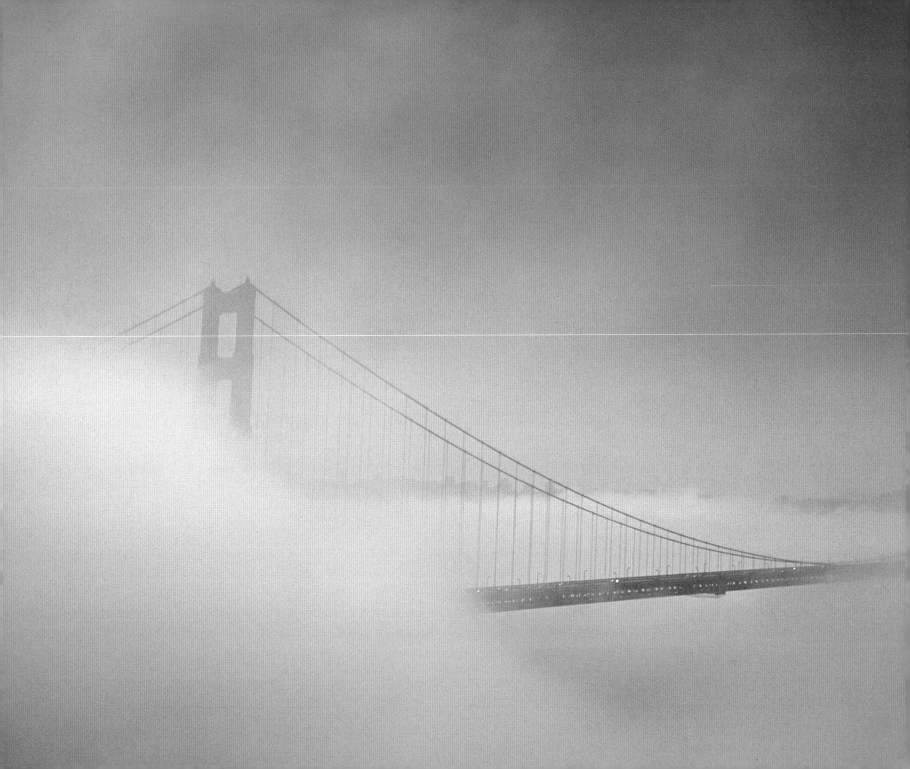

'T is whiter than an Indian pipe,

'T is dimmer than a lace;

No stature has it, like a fog,

When you approach the place.

EMILY DICKINSON

Golden Gate Bridge about to disappear

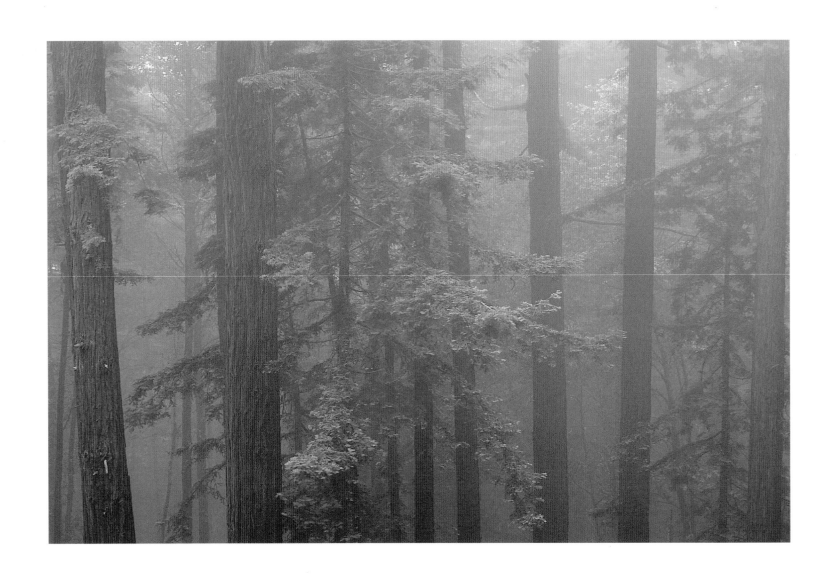

Forest in fog, old La Honda Road, Portola Valley

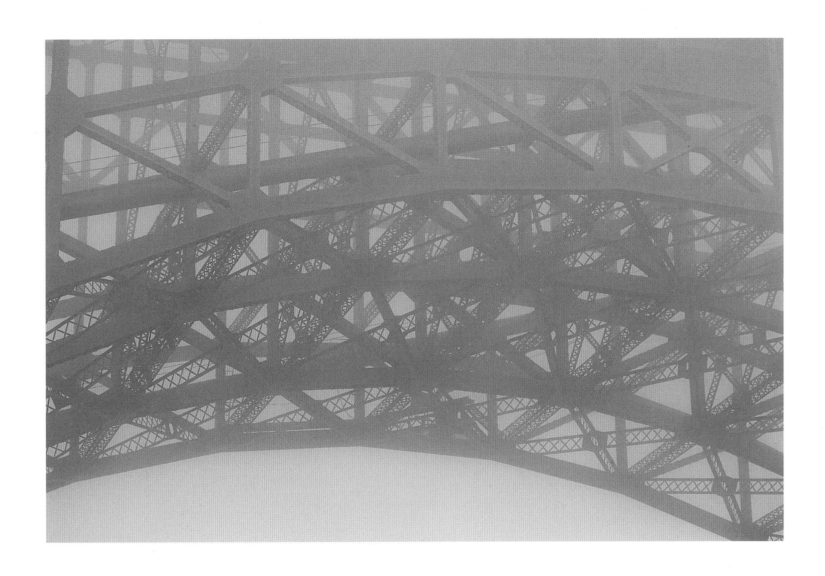

Beneath the Golden Gate Bridge

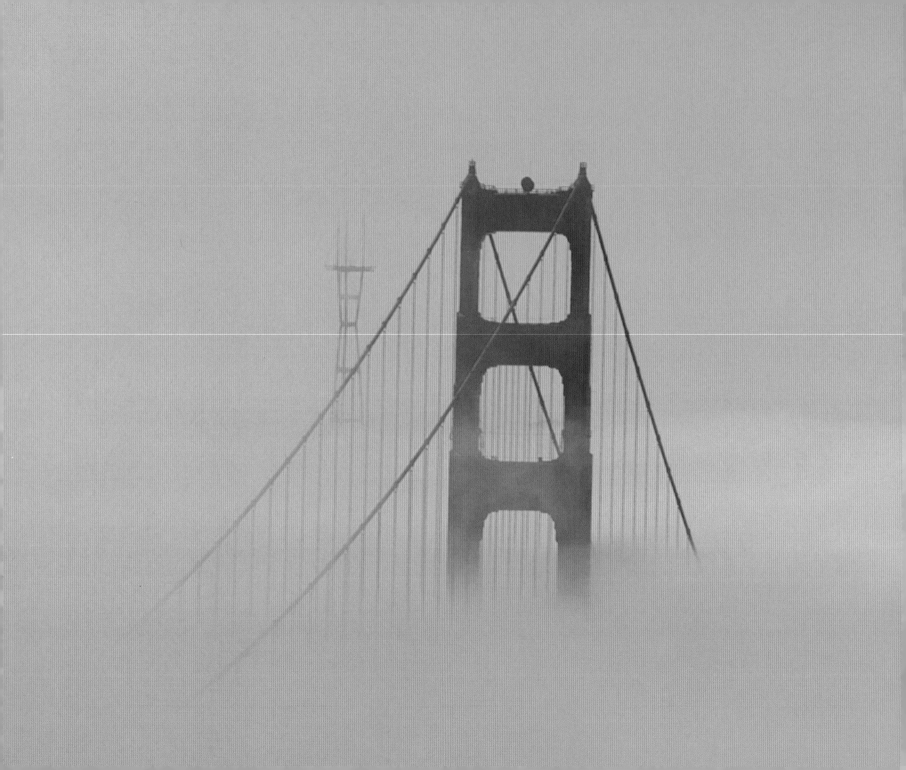

. . . [I] allowed the mystery of the fog

to lay hold of my imagination.

A fresh breeze was blowing, and for a time

I was alone in the moist obscurity. . . .

JACK LONDON

Golden Gate Bridge and Sutro Tower

The air is chill, and the day grows late,

And the clouds come in through the Golden Gate;

Phantom fleets they seem to me,

From a shoreless and unsounded sea;

Their shadowy spars, and misted sails,

Unshattered, have weathered a thousand gales:

Slow wheeling, lo! in squadrons gray,

They part, and hasten along the bay,

Each to its anchorage finding way.

Where the hills of Sausalito swell,

Many in gloom may shelter well,

And others — behold — unchallenged pass

By the silent guns of Alcatraz:

No greetings, of thunder and flame, exchange

The armed isle and the cruisers strange.

Their meteor flags, so widely blown,

Were blazoned in a land unknown;

So, charmed from war, or wind, or tide,

Along the quiet wave they glide.

EDWARD POLLOCK

Sailing on San Francisco Bay past Alcatraz Island

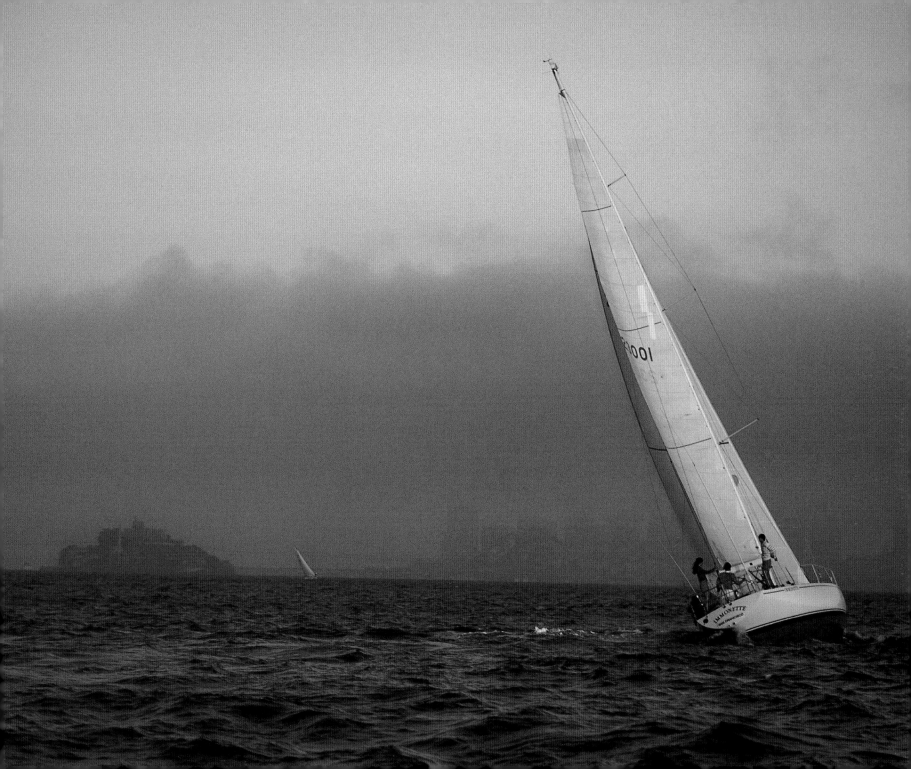

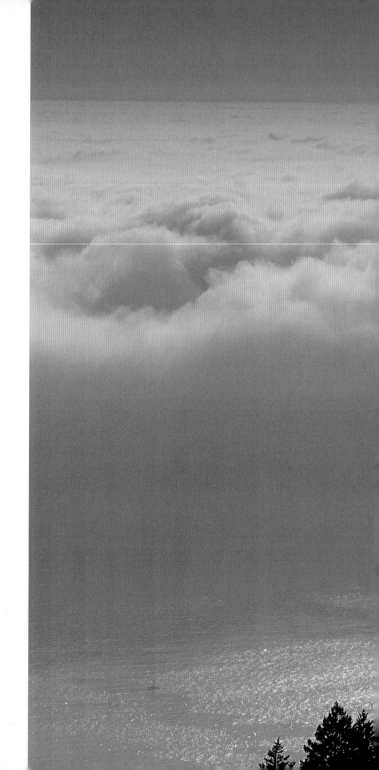

. . . the San Francisco fog, like the bay itself, is born of the violent meeting of land and sea at the place where the ocean has breached the western mountain barrier and invaded the continent's edge. It is conceived out of the cold oceanic deeps and the fertile heat of the Central Valley. It is shaped and given substance by the rotations of the planet and the drift of the currents and the flowing of the rivers of atmosphere.

HAROLD GILLIAM

Above Stinson Beach

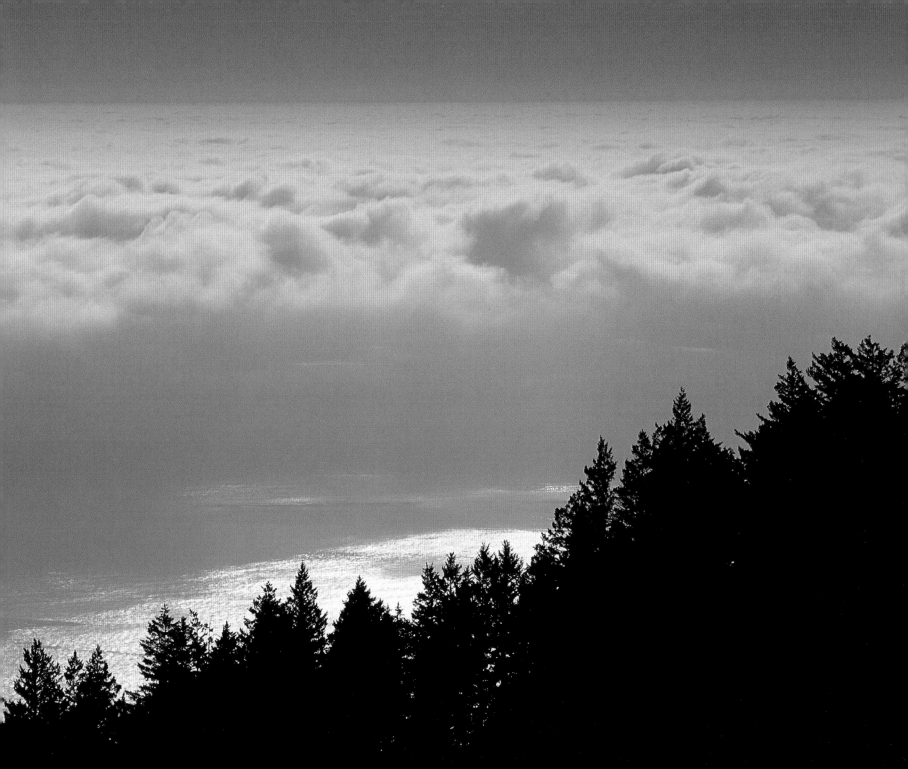

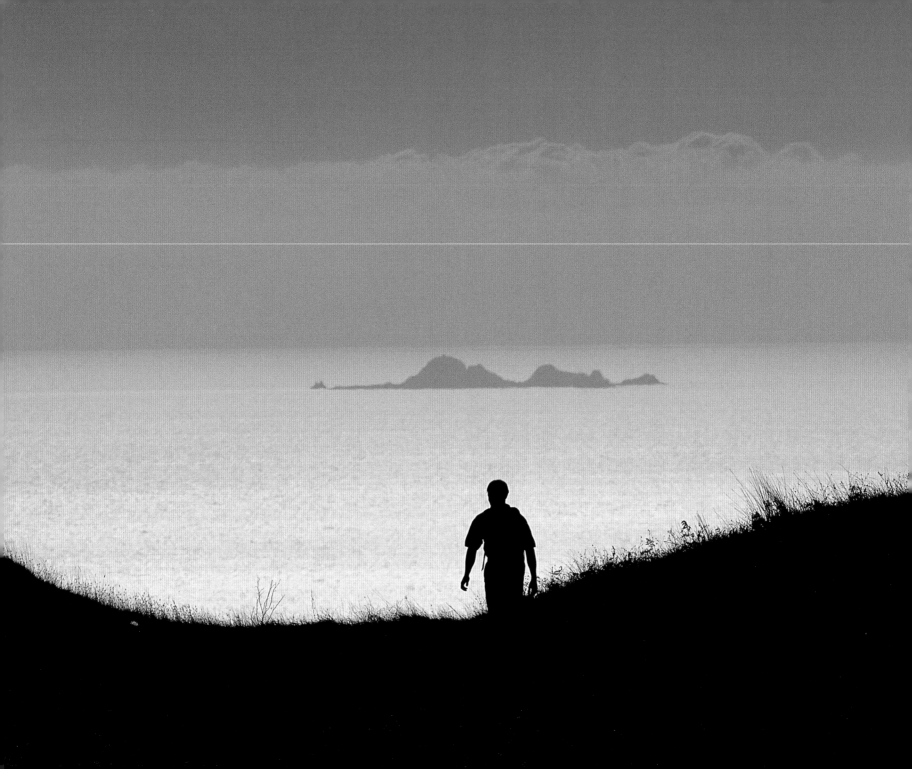

*Very few San Franciscans, much less
Californians, know of that drive from
Willow Camp, to the south and east,
along the poppy-blown cliffs, with the
sea thundering in the sheer depths
hundreds of feet below and the Golden
Gate opening up ahead, disclosing
smoky San Francisco on her many hills.
Far off, blurred on the breast of the sea,
can be seen the Farallones, which Sir
Francis Drake passed on a southwest
course in the thick of what he describes
as a "stinking fog." Well might he call
it that . . . for it was the fog that robbed
him of the glory of discovering
San Francisco Bay.*

JACK LONDON

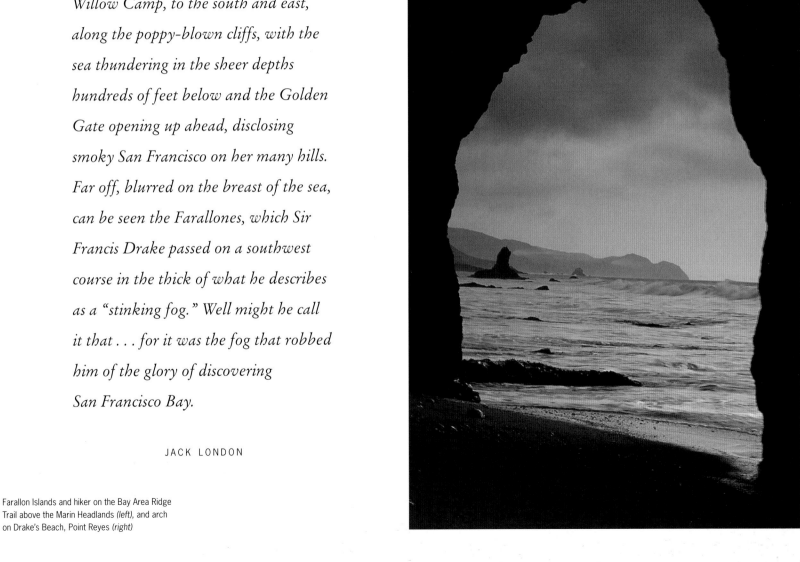

Farallon Islands and hiker on the Bay Area Ridge
Trail above the Marin Headlands *(left)*, and arch
on Drake's Beach, Point Reyes *(right)*

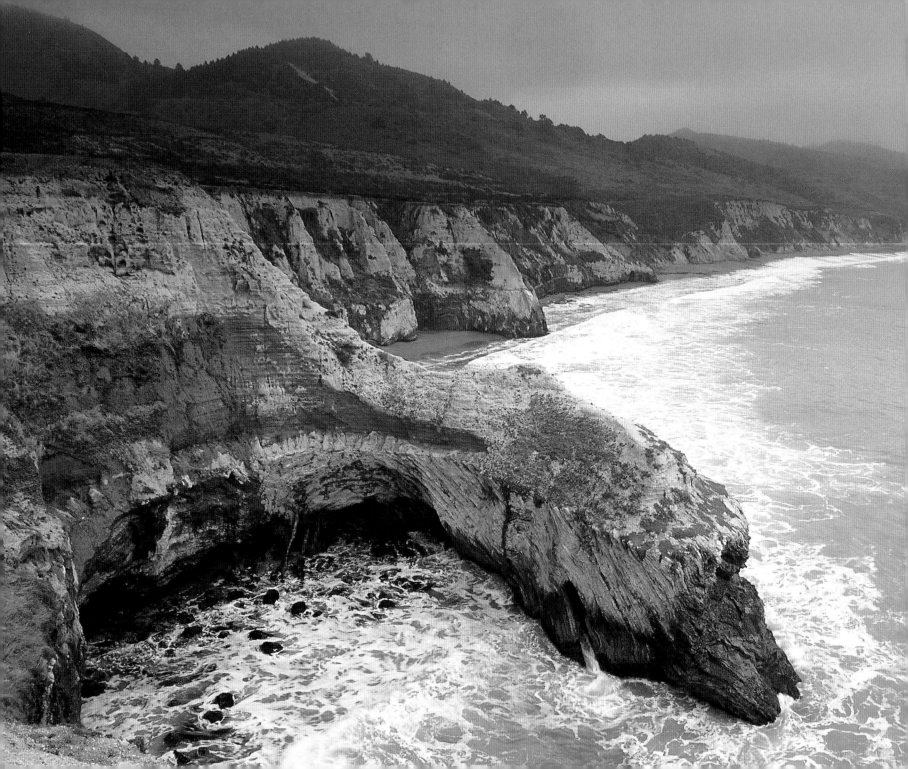

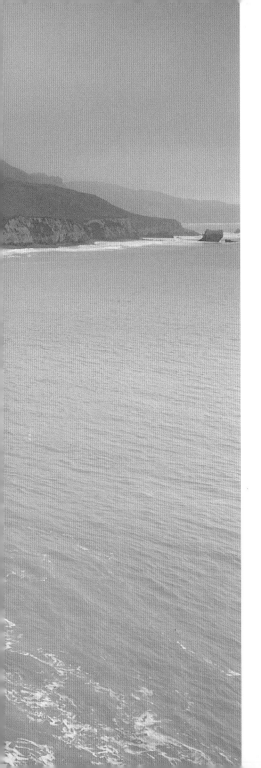

The weather was a continual adventure . . .

The fog, and rain, the grey sky and

the lonely grey stretches of ocean

were like something . . . imagined long ago—

memories of old sea stories read in childhood . . .

WILLA CATHER

Cliffs beyond Sculptured Beach, Point Reyes

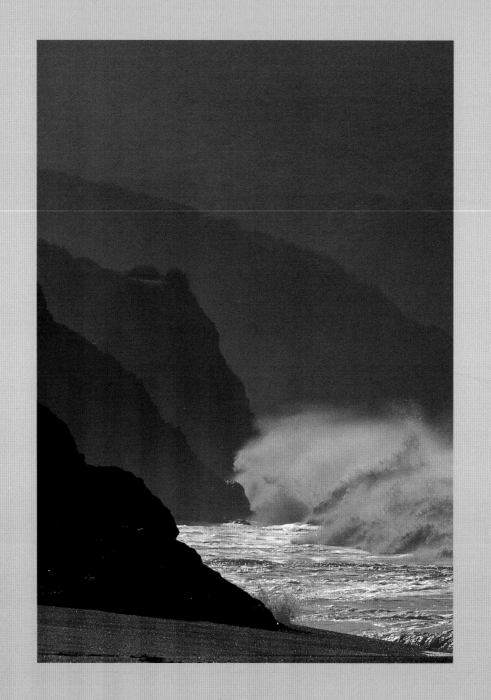

It is true that, older than man and ages to outlast him, the Pacific surf

Still cheerfully pounds the worn granite drum;

But there's no storm; and the birds are still, no song; no kind of excess;

Nothing that shines, nothing is dark;

There is neither joy nor grief nor a person, the sun's tooth sheathed in cloud,

And life has no more desires than a stone.

The story conditions of time and change are all abrogated, the essential

Violences of survival, pleasure,

Love, wrath and pain, and the curious desire of knowing, all perfectly suspended.

In the cloudy light, in the timeless quietness,

One explores deeper than the nerves or heart of nature, the womb or soul,

To the bone, the careless white bone, the excellence.

ROBINSON JEFFERS

Winter waves crashing against the Marin Headlands

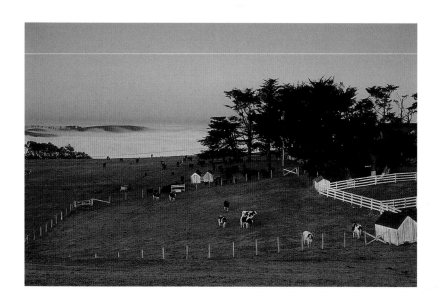

Water that owns the north and west and south

And is all colors and never is quiet,

And the fogs are its breath . . .

Dairy ranch above Tomales Bay *(left)*, and
earth shadow at dawn *(right)*, Mount Tamalpais

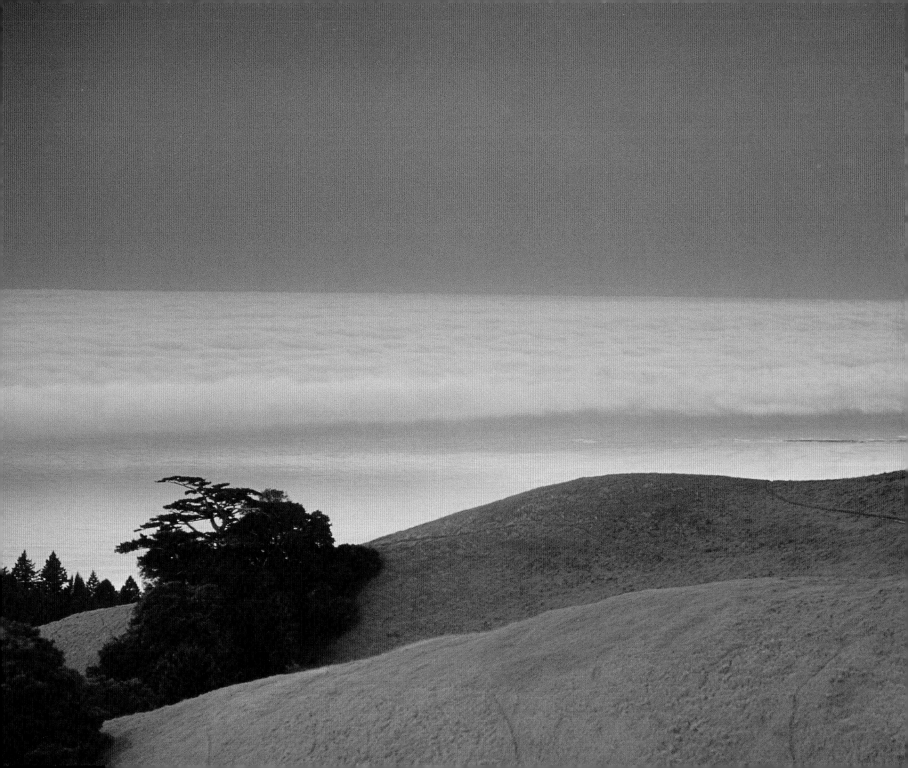

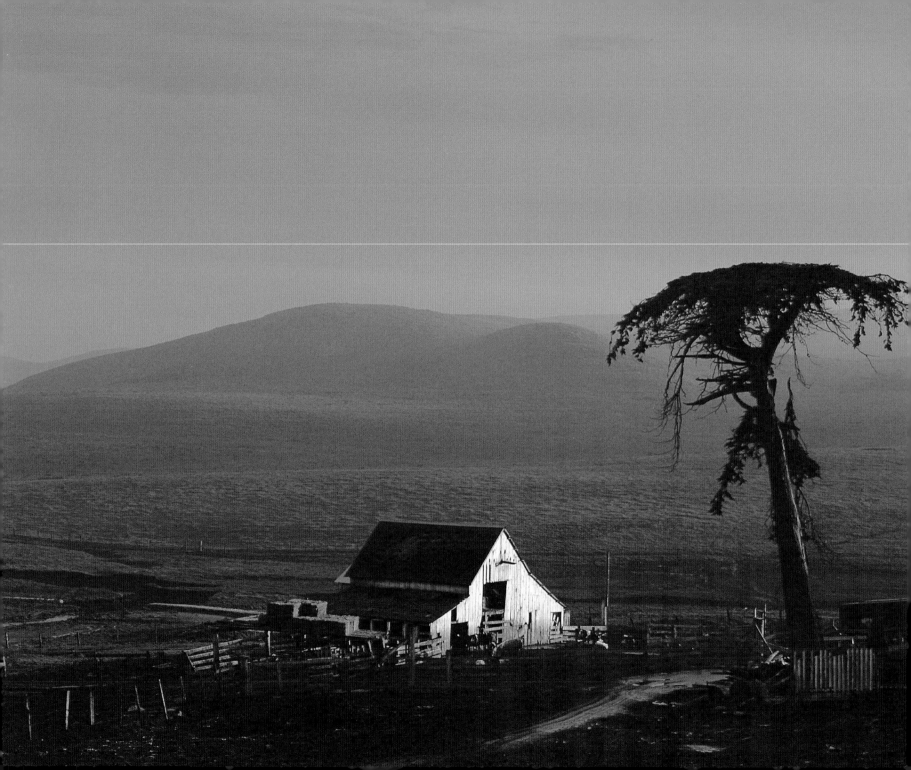

The fog continues to roll in.

Where it's heading I do not know.

It passes in front of the porch like a shifting cloud.

If I stare at it long enough,

it seems that I start to move instead.

DAVID MAS MASUMOTO

Farm near Point Reyes

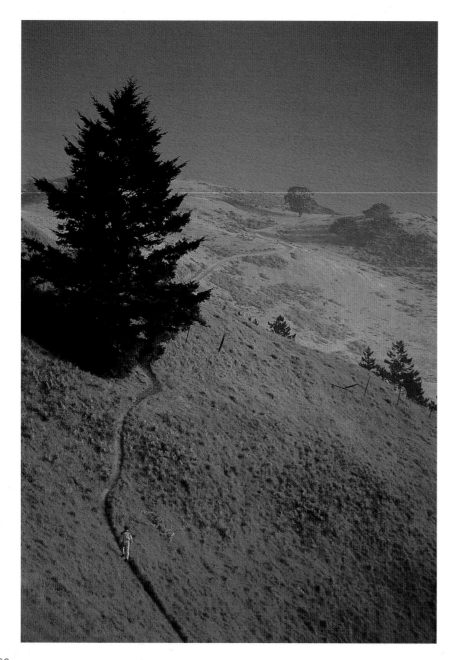

"Swiftly the years, beyond recall:
Solemn the stillness of this Spring morning."
I'll put on my boots & old levis
& hike across Tamalpais.
Along the coast the fog hovers,
Hovers an hour, then scatters.
There comes a wind, blowing from the sea,
That brushes the hills of spring grass.

GARY SNYDER

Hiker on the Coastal Trail *(left)*, and
horse pasture *(right)*, Berkeley Hills

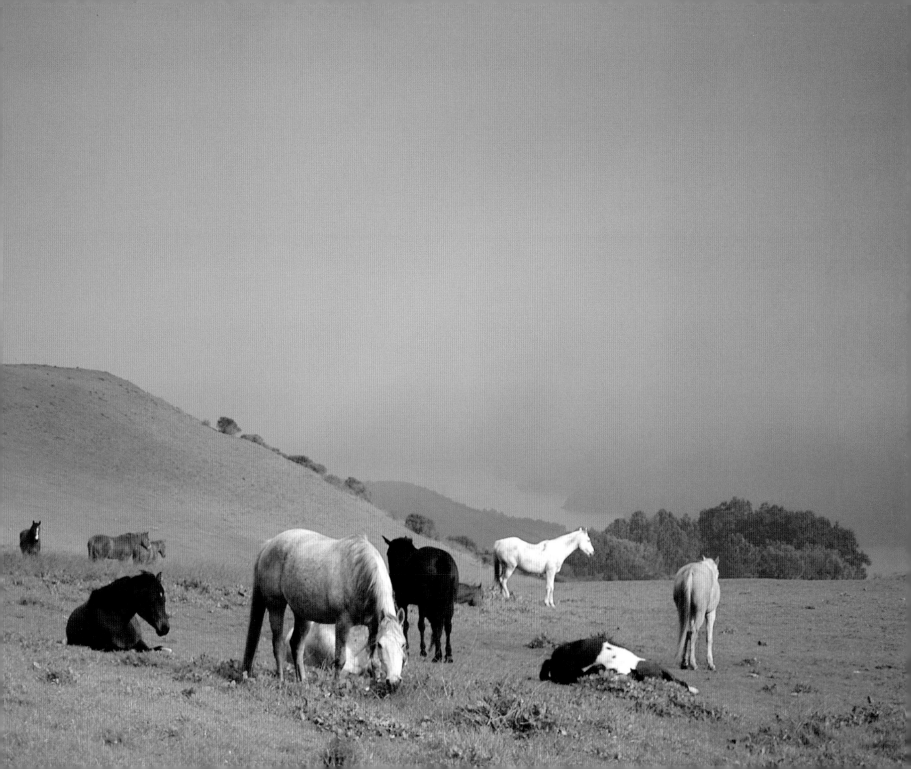

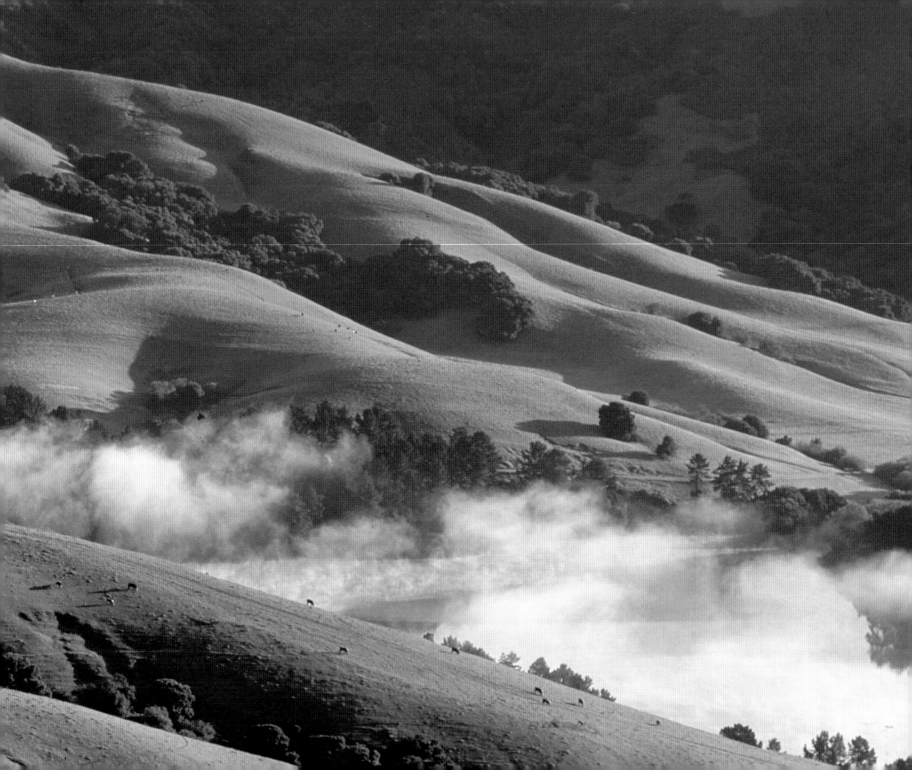

All the Valley quivered, one extended motion, wind
undulating on mossy hills
a giant wash that sank white fog delicately down red runnels
on the mountainside
whose leaf-branch tendrils moved asway
in granitic undertow down—
and lifted the floating Nebulous upward, and lifted the arms of the trees
and lifted the grasses an instant in balance
and lifted the lambs to hold still
and lifted the green of the hill, in one solemn wave . . .

ALLEN GINSBERG

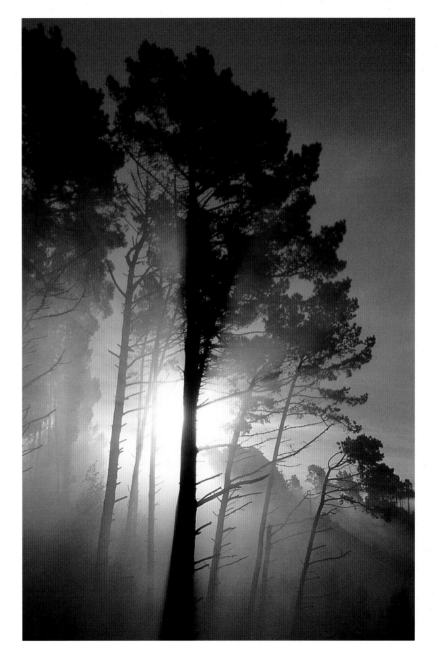

Morning fog over San Pablo reservoir near Orinda *(left)*,
and in the Berkeley Hills *(right)*

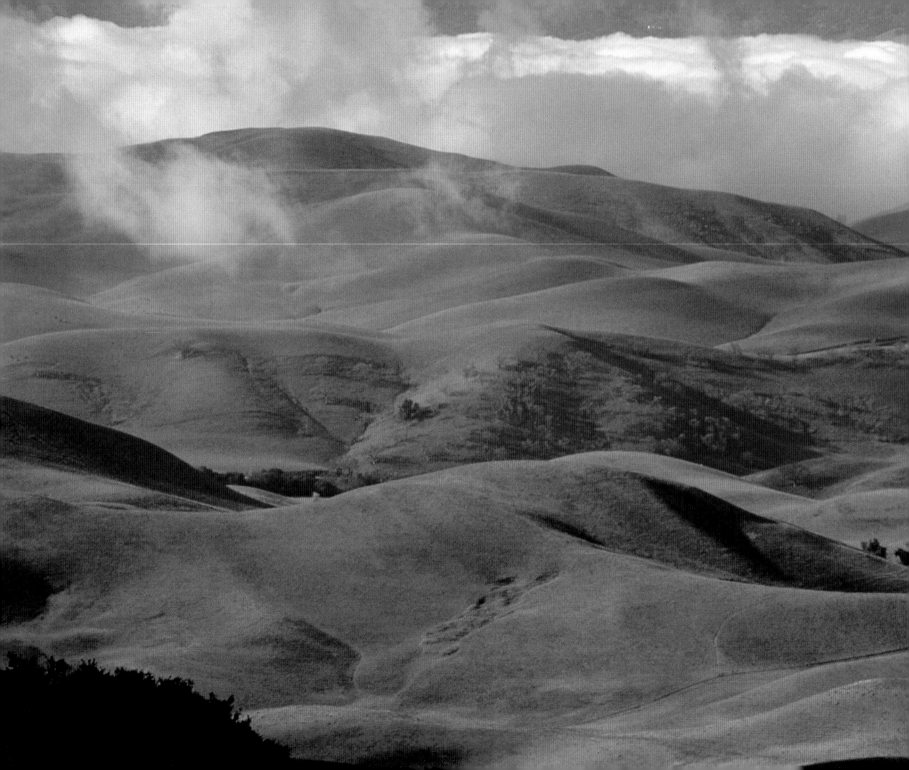

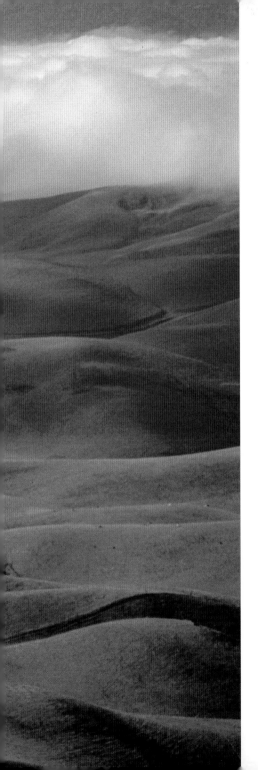

Green is the color of everything

that isn't brown, the tones ranging

like mountains, the colors changing.

You look up toward the hills & fog—

the familiarity of it after so many years

a resident tourist.

AL YOUNG

Rolling hills below Mount Diablo
in the Livermore Valley

73

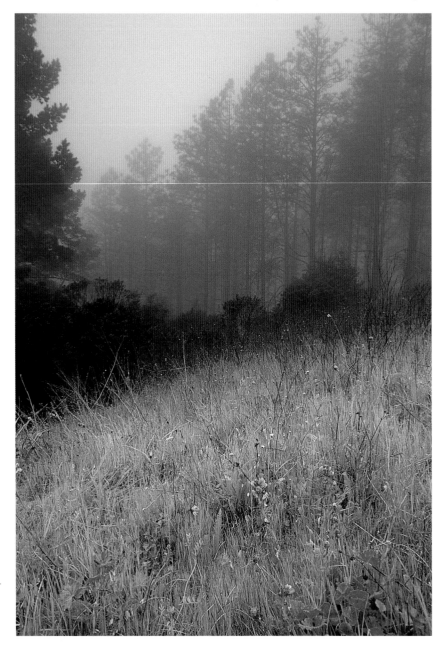

A mere 200 years ago an Indian people
lived on the very land now occupied by
modern-day San Francisco . . .
who with terrible rapidity have almost completely
dropped out of modern consciousness. . . .
In the Ohlone world herds of elk and antelope
wandered over the grasslands.
Grizzly bears, poised along the banks of the rivers,
now and then lunged after silver-flashing salmon.
Giant condors hovered in the sky.
Billows of fog rolled in from the ocean and
settled into the redwood groves.

MALCOLM MARGOLIN

Checkerbloom in fog, Tilden Regional Park,
Berkeley Hills *(left)*, Redwood Regional
Park, Oakland Hills *(right)*, and wind generators
and fog over Altamont Pass *(following pages)*

74

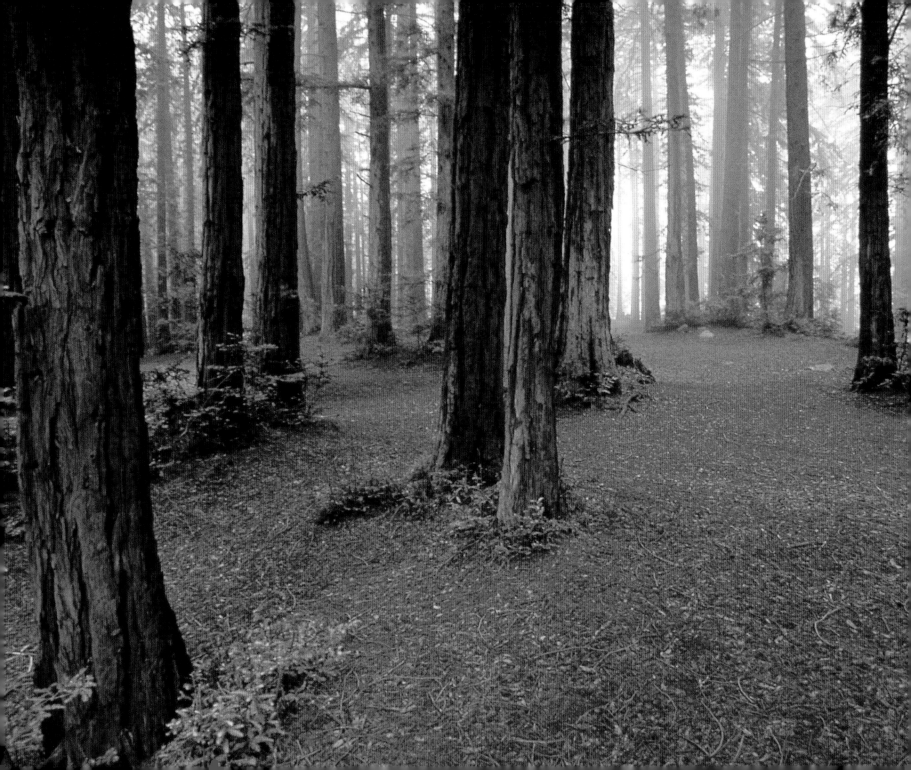

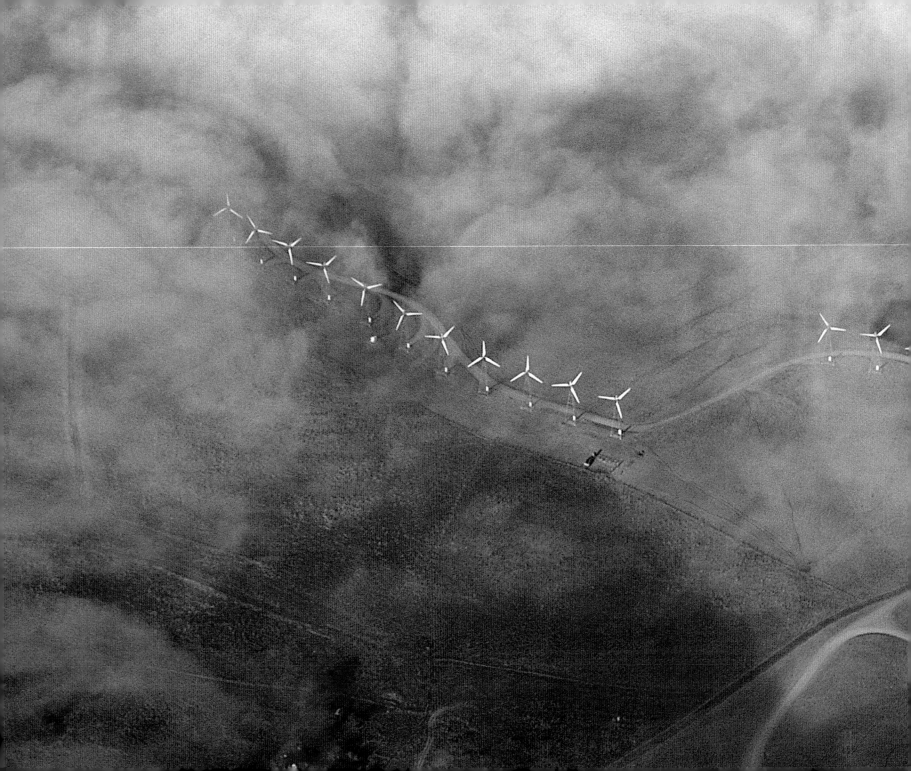

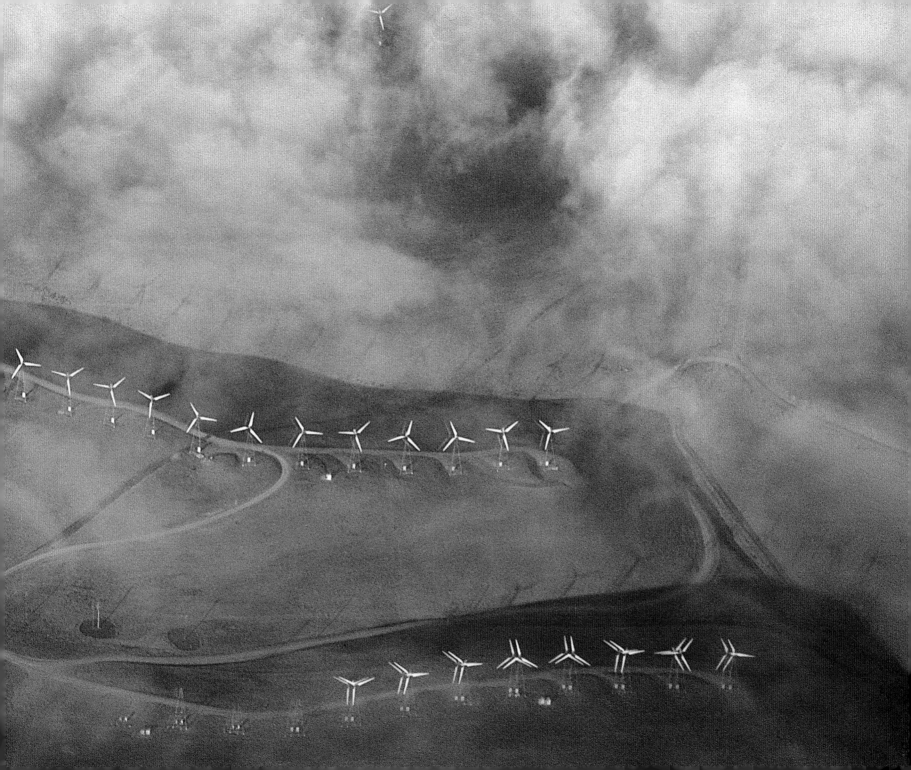

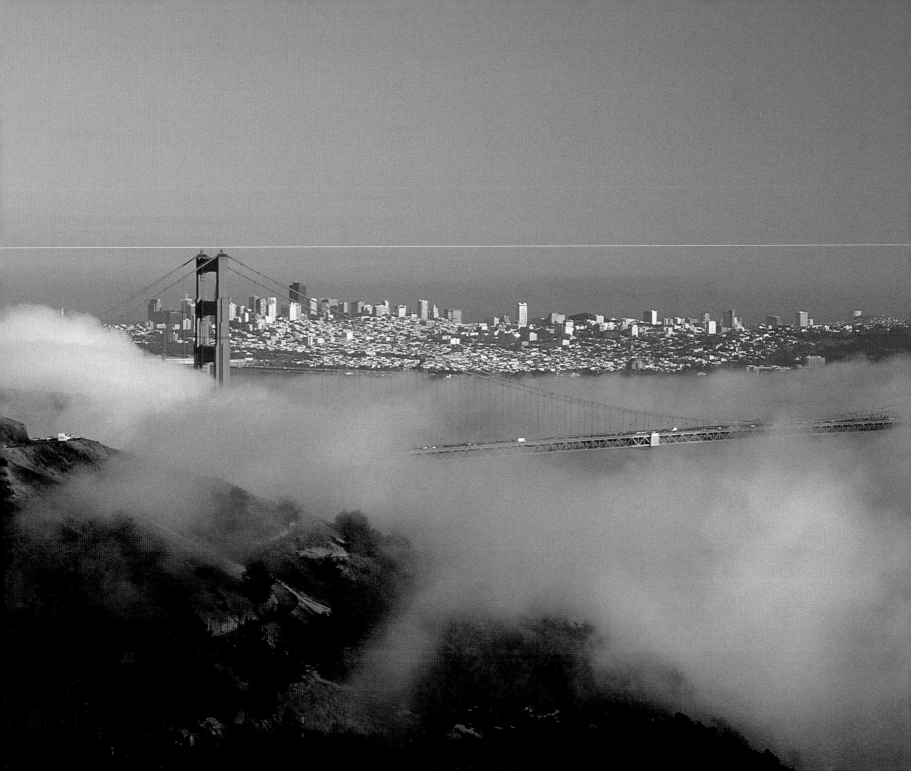

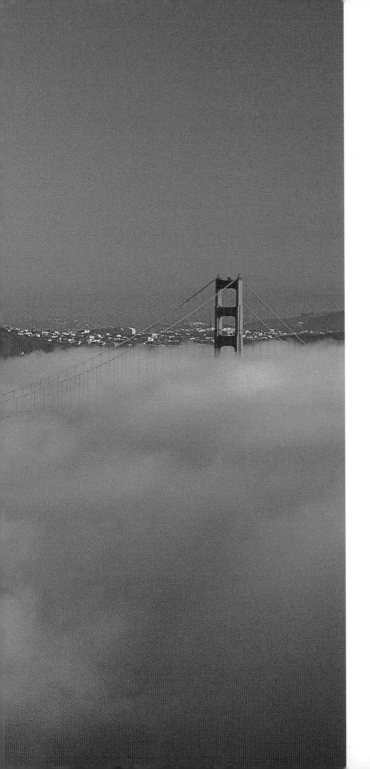

The changing light in San Francisco
 is none of your East Coast light
 none of your
 pearly light of Paris
The light of San Francisco
 is a sea light
 an island light
And the light of fog
 blanketing the hills
 drifting in at night
 through the Golden Gate
 to lie on the city at dawn
And then the halcyon late mornings
 after the fog burns off
 and the sun paints white houses
 with the sea light of Greece
 with sharp clean shadows
 making the town look like
 it had just been painted
But the wind comes up at four o'clock
 sweeping the hills
And then the veil of light of early evening
And then another scrim
 when the new night fog
 floats in
And in that vale of light
 the city drifts
 anchorless upon the ocean

LAWRENCE FERLINGHETTI

San Francisco from the Marin Headlands

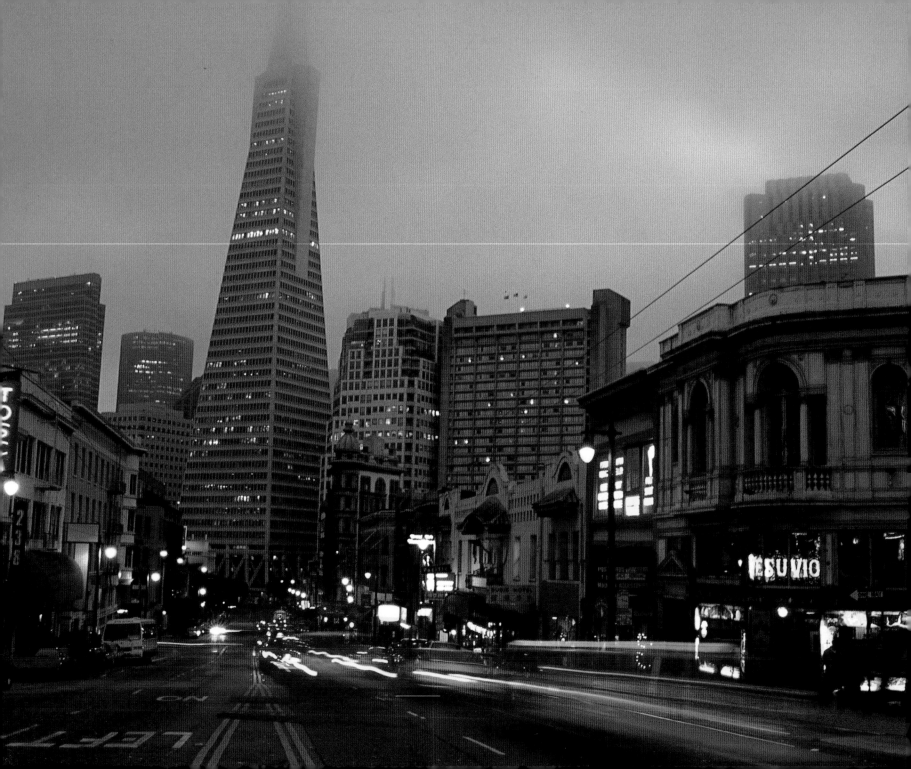

Nothing can oppose the cloud.

Nothing can oppose the gray

that sponges up the rust . . .

unless it is the stone

of its own color

in the tower

where the windows webbed over

are less open than its padlocked door.

LAURA JENSEN

Transamerica Pyramid from North Beach *(left)*,
and rising over downtown San Francisco *(right)*

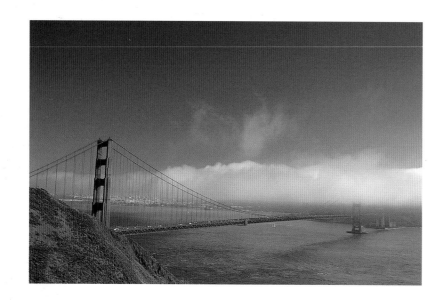

If you go to your window

You will notice a fog drifting in.

This sun is no stronger than a flashlight.

Not all the sweaters

Hung in closets all summer

Could soak up this mist. The fog:

A mouth nibbling everything to its origin . . .

GARY SOTO

Afternoon fog coming through the Golden Gate *(left)*,
and fog bank at sunset over the East Bay Hills *(right)*

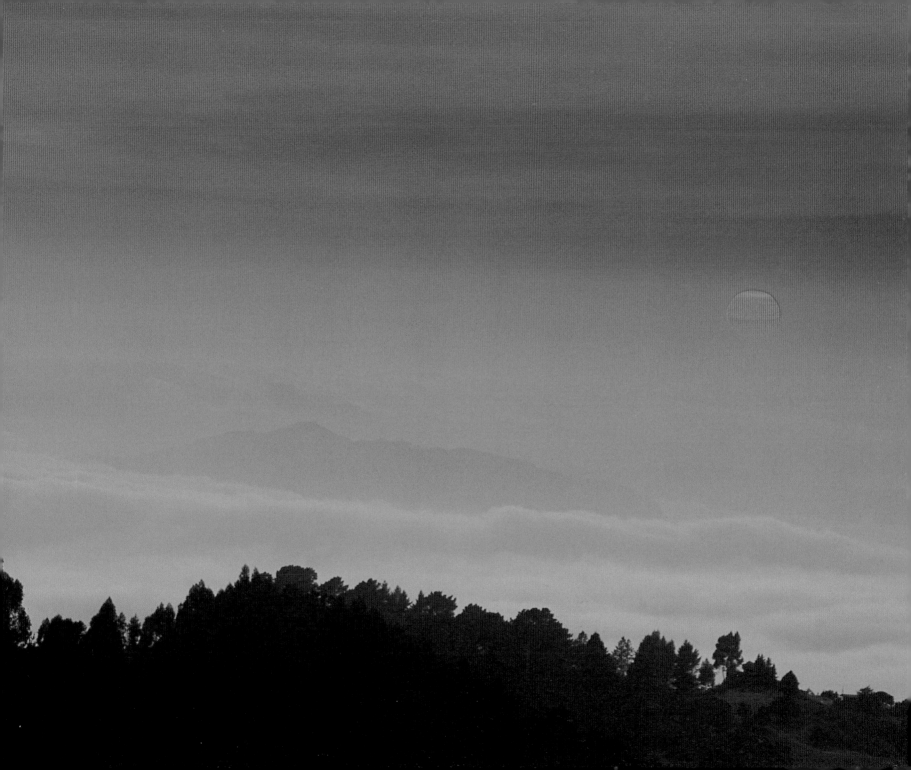

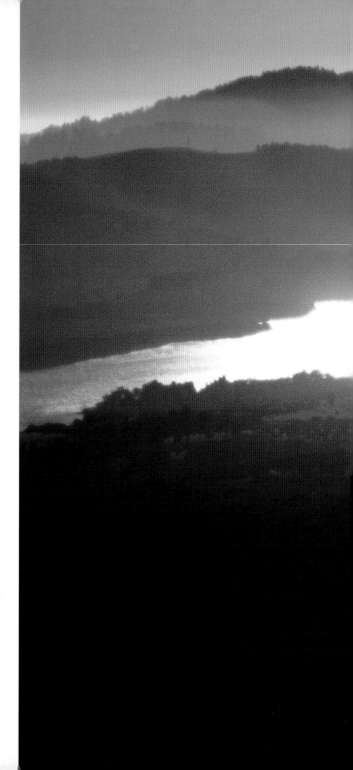

Over the green higher hills to the south,

 the evening fog rolled like herds of sheep

coming to cote in the golden city.

JOHN STEINBECK

Highway 280 and the Crystal Springs
Reservoir south of San Francisco

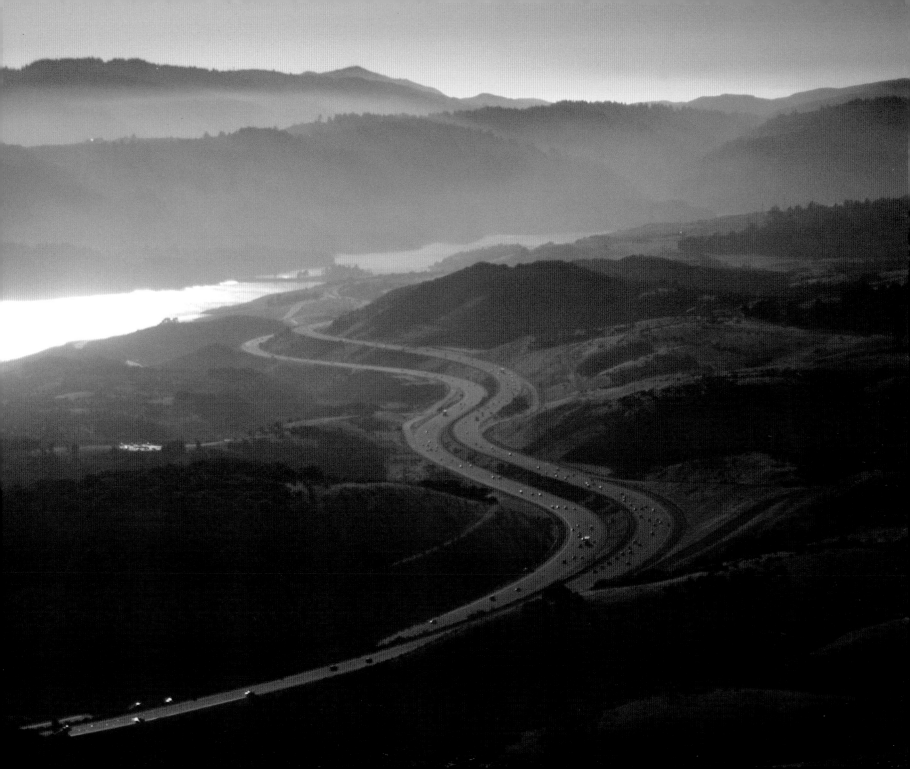

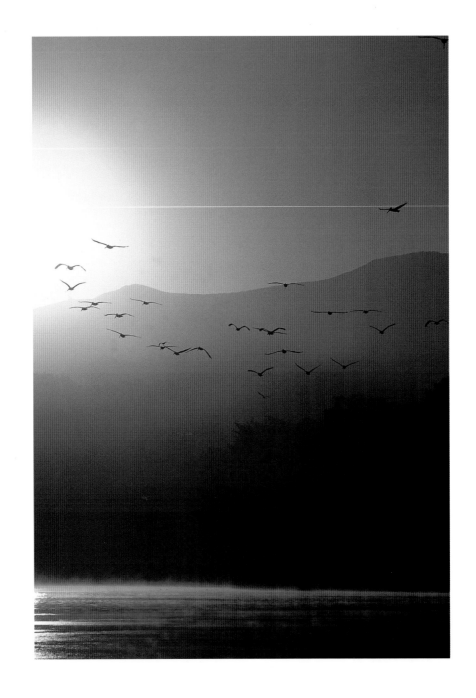

Invisible gulls with human voices cry in the sea-cloud

"There is no room, wild minds,

Up high in the cloud; the web and the feather remember

Three elements, but here

Is but one, and the webs and the feathers

Subduing but the one

Are the greater, with strength and to spare." You dream, wild criers,

The peace that all life

Dreams gluttonously, the infinite self that has eaten

Environment, and lives

Alone, unencroached on, perfectly gorged, one God.

Caesar and Napoleon

Visibly acting their dream of that solitude, Christ and Gautama,

Being God, devouring

The world with atonement for God's sake. . .ah sacred hungers,

The conqueror's, the prophet's,

The lover's, the hunger of the sea-beaks, slaves of the last peace,

Worshippers of oneness.

ROBINSON JEFFERS

Brown pelicans over Rodeo Lagoon,
Marin Headlands

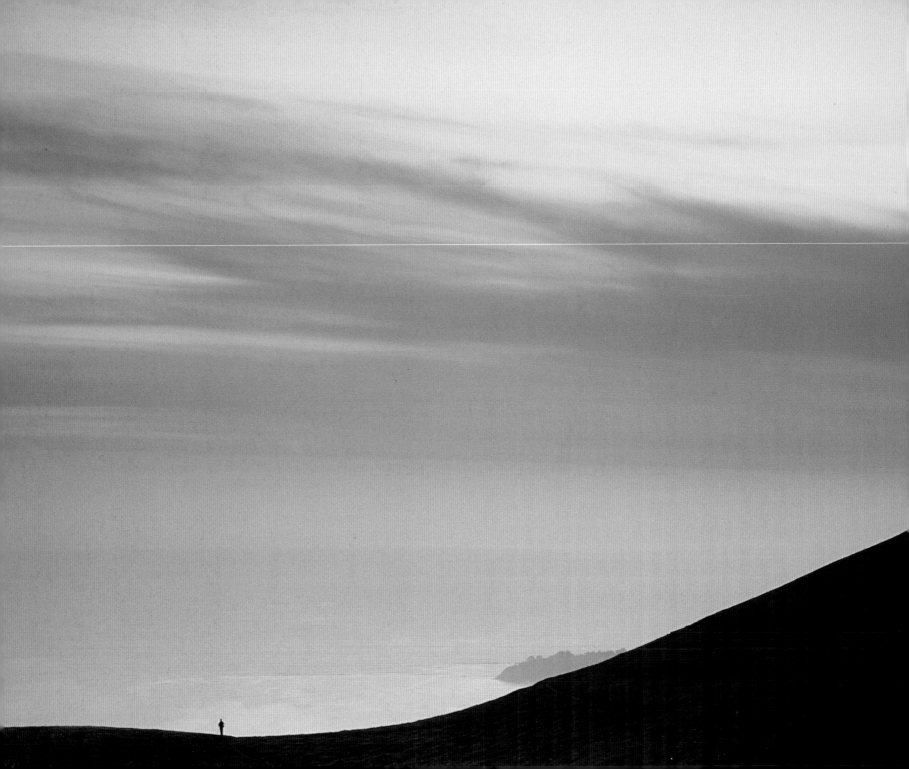

Fogbillows crest over ocean, soundless, unbreaking,
infinitely patient.

Tier after tier, mountains rehearse
the passage from green to evening's amethyst.

Redwings repeat with unslaked thirst
their one sweet song.

The rain's cleared off and the cats are dreamily
watching the lucid world, perched on the fence-rail,
striving for nothing; their shadows grow long.

Delicately,
two hilltop deer
nibble the sky.

DENISE LEVERTOV

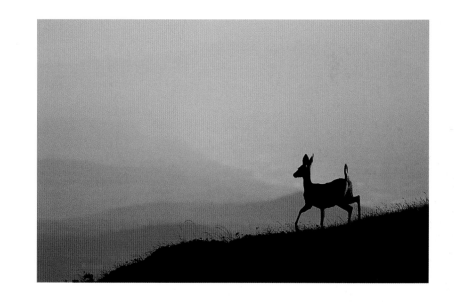

Hiker on Bolinas Ridge in twilight,
Mount Tamalpais (left), and deer in
the mist, Point Reyes (right)

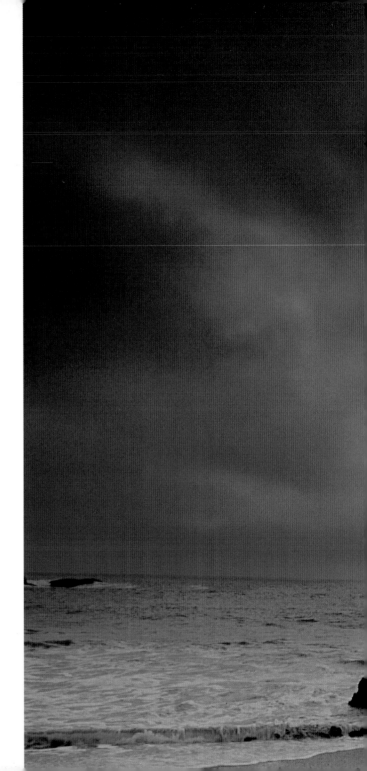

The sun went down in fog tonight,

Dropped like a plummet in the bay;

Only the East was faintly bright,

While all the West was wide and gray.

The glories from the sky are stripped,

The long, smooth breakers meet the land,

Foam-stricken, gray-green, sullen lipped;

I hold the sunset in my hand.

GRACE MACGOWAN COOKE

Sea stacks off the Marin Headlands

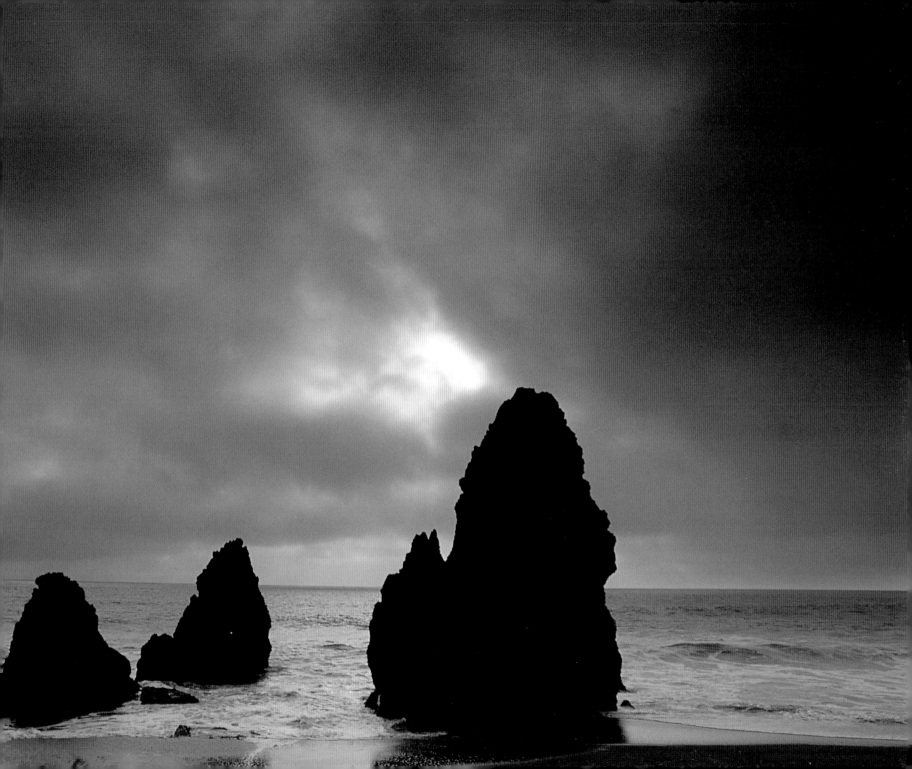

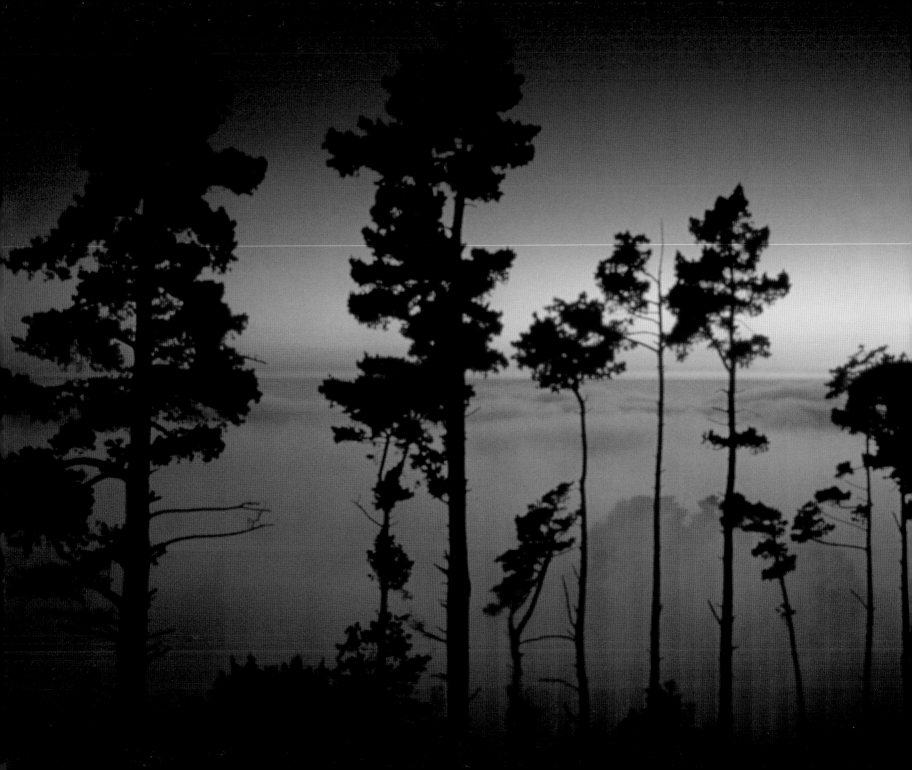

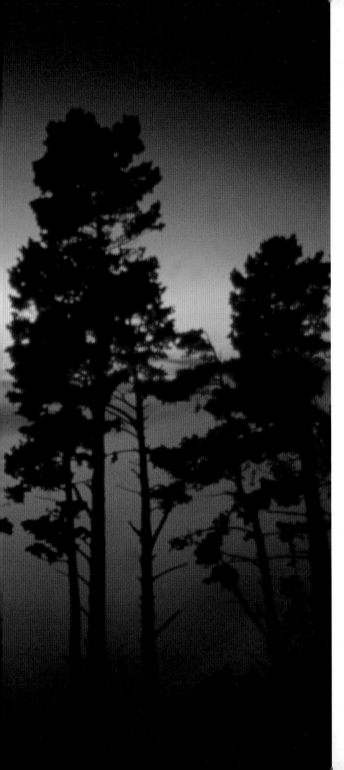

"*We are the Clouds, of splendid hue*

Rising from sea with garments ever new,

We are the breath of Ocean old —

Who rest awhile, then journey far.

Marching with swift, resistless tread

O'er plain and mountain.

We enfold the peaks, enshadow fields,

We are kin to the rivers, the streams and the pools,

We master the wind and the swelling wave;

Weeping, we furrow the well-tilled earth,

Digging swift channels to the Sea."

ARISTOPHANES

Twilight fog through Monterey pines over the Bay

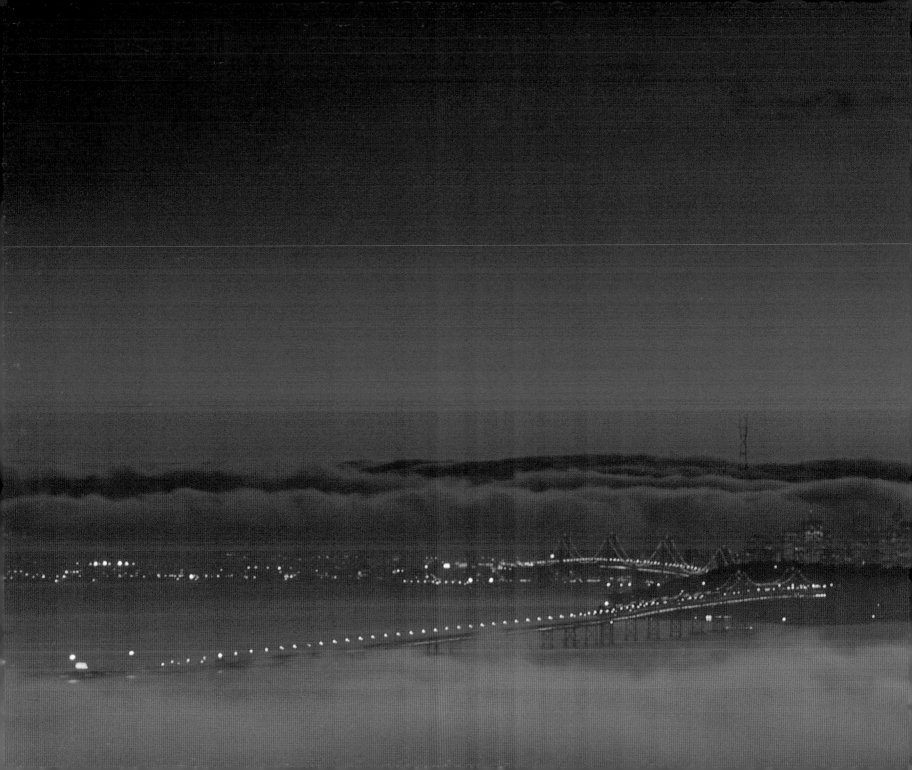

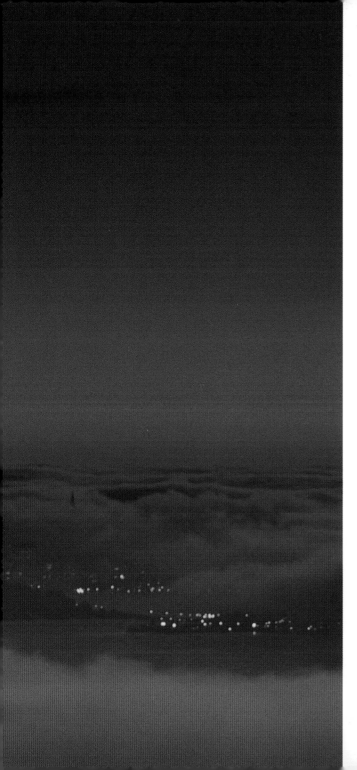

Golden land sunk
Into your bones
Roasted contours
And blue beach
The relationship
Of foams and sands

Flocks of feline fogs
Enter the crevices
Of your deepest bays

Lights sway and dim
Sweat again is air
Heads begin to spin
A milky way swing

Moving to rhythms
From the earth
The grass is high
The moon is bright
Crystal crimson wine
Plus so much night
Reveal the princess
Nude . . .

WALTER MARTINEZ

Sunset over San Francisco
and the Bay Bridge

Through the window I can see the fog

Smothered against the steamy panes of glass.

Fog-cold seeps in under doors,

Numbing feet in a heated room.

There's no keeping it out.

It enters through the tiny cracks of window slots

And soaks through walls.

Place your hand on a wall some heavy morning

When the fog hangs low.

You will find paint grown damp and chill,

Stealing heat from early-kindled stoves.

On such mornings wood won't burn,

Smoke hangs in the flue,

And the salt lumps up in the shakers over the stove.

WILLIAM EVERSON

The Bay Bridge seen down
California Street, San Francisco

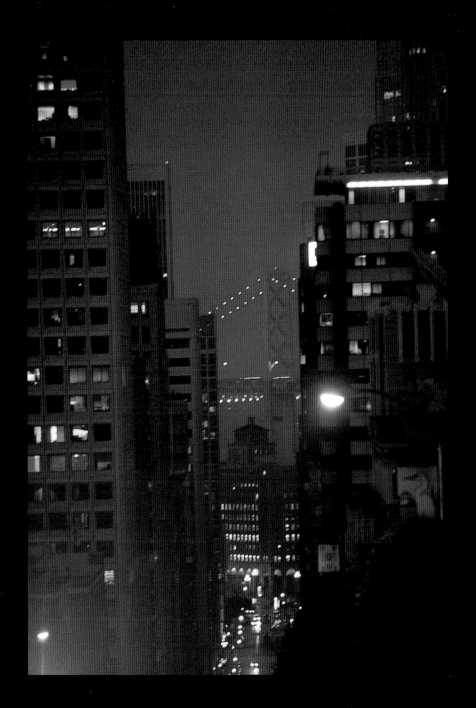

Cold steamy air blew in through two open windows,

bringing with it half a dozen times a minute

the Alcatraz foghorn's dull moaning.

DASHIELL HAMMETT

Coit Tower and Telegraph Hill, San Francisco

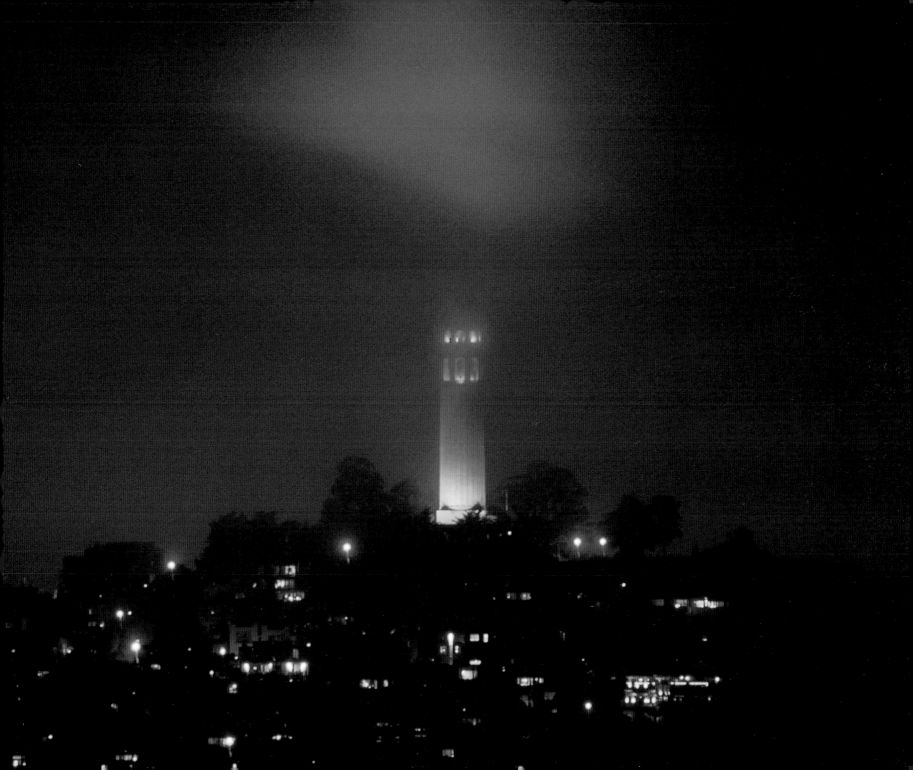

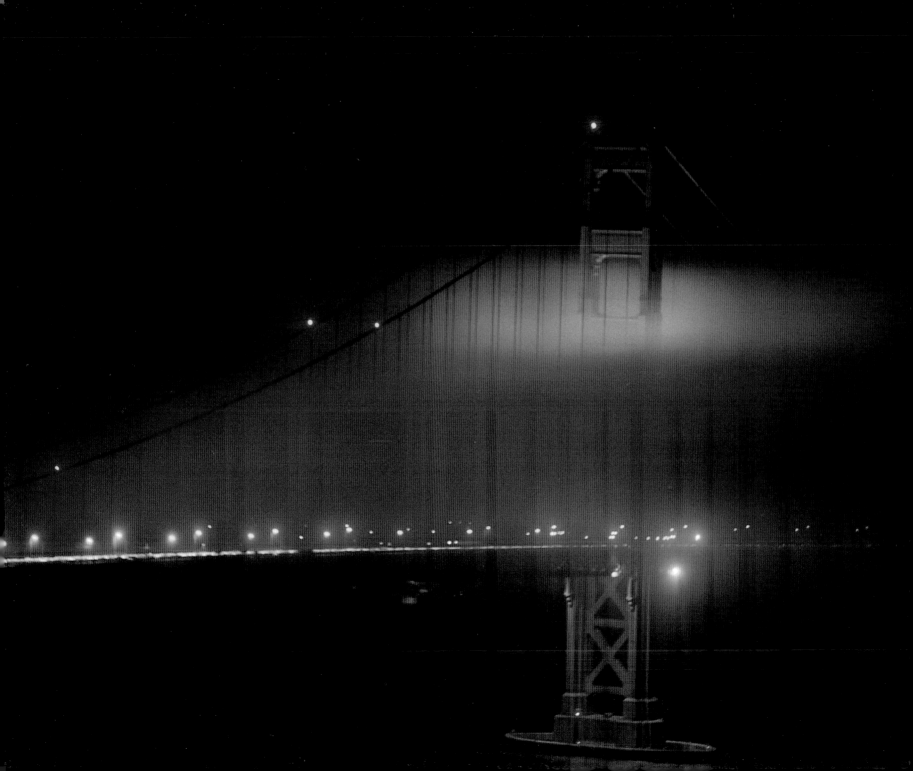

Surely that moan is not the thing
That men thought they were making, when they
Put it there, for their own necessities.
That throat does not call to anything human
But to something men had forgotten,
That stirs under fog. Who wounded that beast
Incurably, or from whose pasture
Was it lost, full grown, and time closed round it
With no way back? Who tethered its tongue
So that its voice could never come
To speak out in the light of clear day,
But only when the shifting blindness
Descends and is acknowledged among us,
As though from under a floor it is heard,
Or as though from behind a wall, always
Nearer than we had remembered? If it
Was we that gave tongue to this cry
What does it bespeak in us, repeating
And repeating, insisting on something
That we never meant? We only put it there
To give warning of something we dare not
Ignore, lest we should come upon it
Too suddenly, recognize it too late,
As our cries were swallowed up and all hands lost.

W. S. MERWIN

Night fog over the Golden Gate Bridge

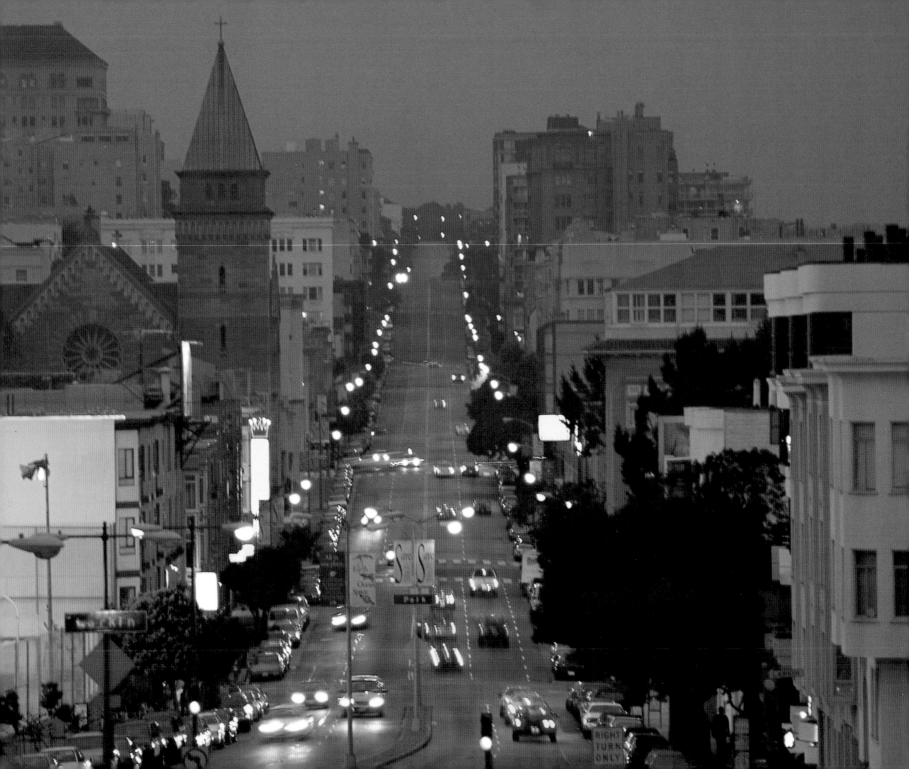

Things to Do Around San Francisco

Catch eels in the rocks below the Palace of the Legion of Honor.
Four in the morning—congee at Sam Wo.
Walk up and down Market, upstairs playing pool,
Turn on at Aquatic Park—seagulls steal bait sardine
Going clear out to Oh's to buy bulghur.
Howard Street Goodwill
Not paying traffic tickets; stopping the phone.
Merry-go-round at the beach, the walk up to the cliff house,
* sea lions and tourists—the old washed-out road that goes on—*
Play chess at Mechanics'
Dress up and go looking for work
Seek out the Wu-t'ung trees in the park arboretum.
Suck in the sea air and hold it—miles of white walls—
* sunset shoots back from somebody's window high in the*
* Piedmont hills*

Get drunk all the time. Go someplace and score.
Walk in and walk out of the Asp
Hike up Tam
Keep quitting and starting at Berkeley
Watch the pike in the Steinhart Aquarium: he doesn't move.
Sleeping with strangers
Keeping up on the news
Chanting sutras after sitting
Practicing yr frailing on guitar
Get dropped off in the fog in the night
Fall in love twenty times
Get divorced
Keep moving—move out to the Sunset
Get lost—or
Get found

GARY SNYDER

Foggy night on Broadway, San Francisco

It is and has everything.

. . . Seafood is cheap.

Chinese food is cheaper, & lovely.

Californian wine is good.

The iced bock beer is good.

What more?

And the city is built on hills;

it dances in the sun for nine months of the year;

& the Pacific Ocean never runs dry.

DYLAN THOMAS

The city from Fisherman's Wharf *(left)*,
and North Beach in fog *(right)*

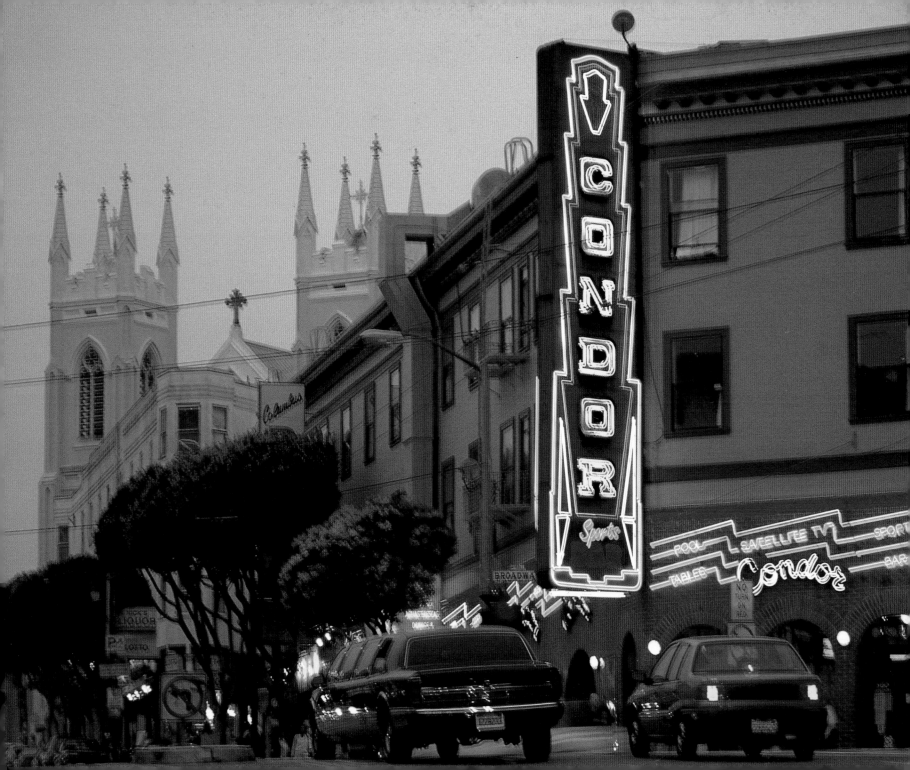

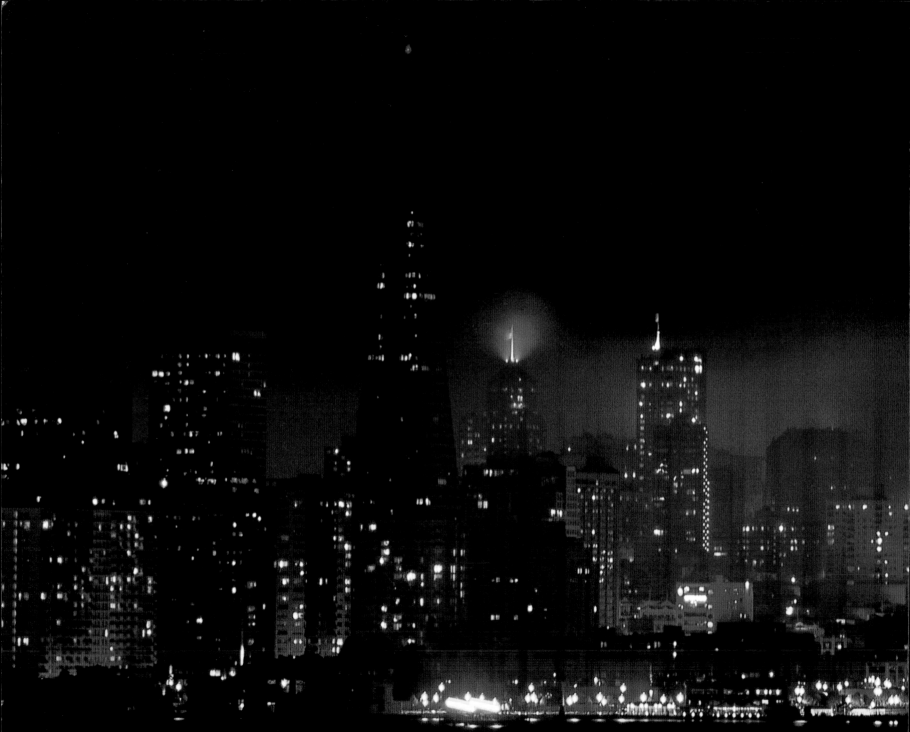

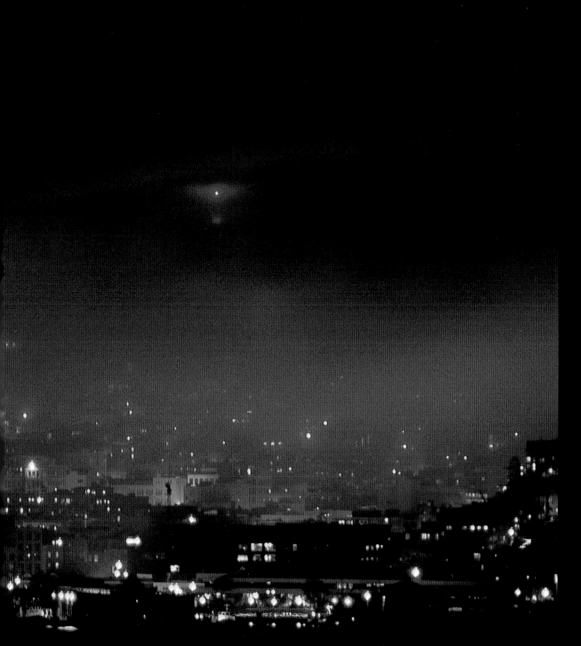

When the sun is sinking slow
 Behind the mountains blue and white,
And the mist upon the town is falling low;
When the mocker's sleepy note
Seems to stifle in his throat—
 Then to us in California, it is night.

WILLIAM NAUNS RICKS

San Francisco at night from Yerba Buena Island

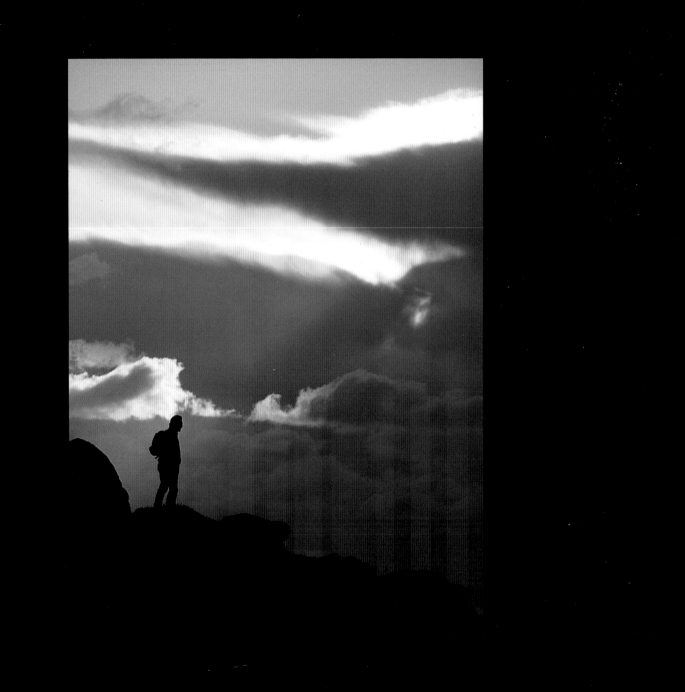

Fog

You are all things to me—
All mystery!
A silver harem veil
That hides dark eyes
And smiles glad surprise;
You are a mist of tears—
The welling up of sorrow in the heart;
You are a dull, gray cloak of fears;
And you are mother-wings
That cover all small frightened things
And guard them in a world apart;
You are white, yearning, gentle hands
That soothing touch my aching breast
And bring me rest;
You are the cool, sweet breath of Night
Whispering all dream-delight
To tired lands:
You are the wild, brave, free
Salt-spume of the restless sea;—
All things! All mystery!

ANNA BLAKE MEZQUIDA

Tomales Point, Point Reyes

BIBLIOGRAPHY

Aristophanes. *The Clouds.* 419 B.C.E.

Bakker, Elna. *An Island Called California.* Berkeley: UC Press; 1971.

Bierce, Ambrose. *The Collected Works.* New York: Neale Pub. Co., 1909–1912.

Caen, Herb. *Baghdad by the Bay.* Doubleday, a division of Random House, Inc.; 1949.

Cather, Willa. *One of Ours.* New York: A. A. Knopf, 1922.

Cooke, Grace MacGowan, et al. *Golden Songs of the Golden State,* selected by Marguerite Wilkinson. Chicago: A. C. McClurg & Co., 1917.

Daniels, Douglas Henry. *Pioneer Urbanites: A Social and Cultural History of Black San Francisco;* foreword by Nathan Irvin Huggins. Philadelphia: Temple University Press, 1980.

Dickinson, Emily. *Collected Poems.* Philadelphia: Courage Books, 1991.

Everson, William. *The Residual Years: Poems 1934–1948.* New York: New Directions Publishing Corporation, 1968.

Everwine, Peter. *Collecting the Animals.* Pittsburgh, Pennsylvania: Carnegie Mellon University Press, 2000.

Ferlinghetti, Lawrence. *How to Paint Sunlight: Lyric Poems and Others (1997–2000).* New York: New Directions Publishing Corporation, 2001.

Frost, Robert. *Collected Poems of Robert Frost.* Garden City, New York: Halcyon House, 1942.

Gilliam, Harold. *San Francisco Bay.* New York: Doubleday & Company, Inc., 1957.

Ginsberg, Allen. *Selected Poems, 1947–1995.* New York: HarperCollins Publishers, Inc., 1996.

Hammett, Dashiell. *The Maltese Falcon.* San Francisco: North Point Press, 1984.

Harte, Bret, et al. *The Western Gate: A San Francisco Reader.* New York: Farrar, Straus and Young, 1952.

Hass, Robert. *FIELD GUIDE.* New Haven, Connecticut: Yale University Press, 1973.

Jeffers, Robinson. *The Selected Poetry of Robinson Jeffers.* Palo Alto, California: Stanford University Press, 2001.

Jensen, Laura. *Bad Boats.* New York: Ecco Press, 1977.

Levertov, Denise. *Oblique Prayers.* New York: New Directions Publishing Corporation, 1984.

London, Jack. *The Human Drift.* New York: Macmillan, 1917.

London, Jack. *The Sea Wolf.* New York: Buccaneer Books, 1990.

Margolin, Malcolm. *The Ohlone Way: Indian Life in the San Francisco-Monterey Bay Area.* Berkeley: Heyday Books, 1978.

Martínez, Walter, et al. *Yardbird Reader,* Volume 2. Berkeley: Yardbird Publishing Cooperative, 1974.

Mas Masumoto, David. *Epitaph for a Peach.* San Francisco: Harper San Francisco/Harper Collins, 1995.

McAdie, Alexander. *The Clouds and Fogs of San Francisco.* San Francisco: A. M. Robertson, 1912.

Merwin, W. S. *The Drunk in the Furnace.* New York: The Macmillan Company, 1960.

Mezquida, Anna Blake. *A-Gypsying.* San Francisco: Marvin Cloyd, 1922.

Milosz, Czeslaw. *Visions of San Francisco Bay,* trans. Richard Lourie. New York: Farrar, Straus and Giroux, Inc., 1975.

Pollock, Edward, et al. *Golden Songs of the Golden State,* selected by Marguerite Wilkinson. Chicago: A. C. McClurg & Co., 1917.

Ricks, William Nauns, et al. *Califia: The California Poetry.* Berkeley: Y'Bird Books, 1979.

Snyder, Gary. *Left Out in the Rain: New Poems: 1947–1985.* San Francisco: North Point Press, 1986.

Snyder, Gary. *Mountains and Rivers Without End.* Washington, D.C.: Counterpoint Press, 1996.

Soto, Gary. *New and Selected Poems.* San Francisco: Chronicle Books, 1995.

Steinbeck, John. *Travels With Charley.* New York: Penguin Books, 1980.

Sterling, George. *Selected Poems.* New York: Henry Holt and Company, 1923.

Stevenson, Robert Louis. *Silverado Squatters.* San Francisco: The Grabhorn Press, 1952.

Thomas, Dylan. *The Collected Letters of Dylan Thomas.* New York: Macmillan Publishing Company, 1986.

Urmy, Clarence. *A California Troubadour.* San Francisco: A. M. Robertson, 1912.

Wong, Shawn H. *Homebase.* New York: Dutton Signet, a division of Penguin Group (USA) Inc., 1991.

Young, Al, et al. *Writing Home: Award-Winning Literature from the New West.* Berkeley: Heyday Books, 1999.

Concept and design by Jennifer Barry Design, Fairfax, CA.
Layout production by Kristen Wurz.

Published by Sasquatch Books
Printed in Hong Kong
Distributed by Publishers Group West
09 08 07 06 05 04 03 6 5 4 3 2 1

Library of Congress Cataloging-in-Publication Data

Rowell, Galen A.
Fog city: impressions of the San Francisco Bay area in fog / photographs by Galen Rowell;
edited by Jennifer Barry; foreword by Harold Gilliam.
p. cm.
Includes bibliographical references.
ISBN 1-57061-346-X
1. San Francisco Bay Area (Calif.)—Pictorial works.
2. Fog—California—San Francisco Bay Area—Pictorial works. I. Barry, Jennifer. II. Title.

F868.S156 R69 2003
979.4'61'002—dc21

Sasquatch Books / 119 S. Main Street, Suite 400 / Seattle, Washington 98104
206/467-4300 / www.sasquatchbooks.com / books@sasquatchbooks.com

Photo captions: cover, San Francisco in the fog from the Berkeley Hills; p. 2, Night view from the north tower of
the Golden Gate Bridge; pp. 4–5, San Francisco in fog beyond the vast wildlands of western Marin County.